To Beth: On the birth

of her 2nd child.

From: Barb Hammer

Victoria

BOOK OF DAYS

Victoria
BOOK OF DAYS

HEARST BOOKS
NEW YORK

Copyright notices, permissions, and acknowledgments
appear on pages 140–143.

Library of Congress Catalog Card Number: 89-084146
ISBN: 0-688-08067-7

Printed in Singapore
First Edition
3 4 5 6 7 8 9 10

For *Victoria*–
Nancy Lindemeyer, Editor
Bryan E. McCay, Art Director
John Mack Carter, Director, Magazine Development

Edited by Linda Sunshine
Designed by Larry Kazal
Produced by Smallwood & Stewart, New York City

NOTICE: Every effort has been made to locate the
copyright owners of the material used in this book.
Please let us know if an error has been made, and we
will make any necessary changes in subsequent
printings.

Contents

INTRODUCTION

*T*he world is filled with all manner of things, so goes the saying. And little wonder that many of those that are beautiful and interesting—that are treasures—share a single name, Victoria. From literature to architecture, from fine porcelain to furniture, from portraiture to all the decorative arts, the word "Victorian" has come to be synonymous with style and taste.

Today, in a world where we pride ourselves on our efficiency and practicality, there is precious little time to cherish quality and the simple joys of life—a return to loveliness, if you will. Our magazine, *VICTORIA*, has taken

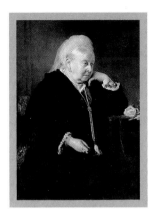

inspiration from the graceful, gracious days of her era, and proudly shares a link to such a worthy namesake as England's longest-reigning queen.

In *VICTORIA'S* BOOK OF DAYS, we invite you to savor the splendor of life's enduring charms. This journal combines the most beautiful, evocative art and photography from *VICTORIA* with poems and prose excerpts from a wide range of beloved writers: Emily Dickinson, Elizabeth Barrett Browning, Charles Dickens, Walt Whitman, Emily Brontë, Jane Austen, and many others. Sprinkled throughout are ideas for such Victorian fancies as scented waters, potpourris, and herbal vinegars. We also provide space for you to include your own cherished thoughts, ideas, and remembrances. Thus, this book becomes yours as much as it was ours when we selected the words and pictures.

A name has the ability to set a mood, to evoke an era. It's no wonder then that the name Victoria is bestowed upon objects, and often personalities, of beauty and creativity. Make this book your own by filling its pages with your personality. Share with us the spirit of Victoria, this timeless point of view. And savor the most romantic and melodic days of the year.

The Editors, VICTORIA

*Comes the fresh Spring
in all her green
completed.*

Elizabeth Barrett Browning

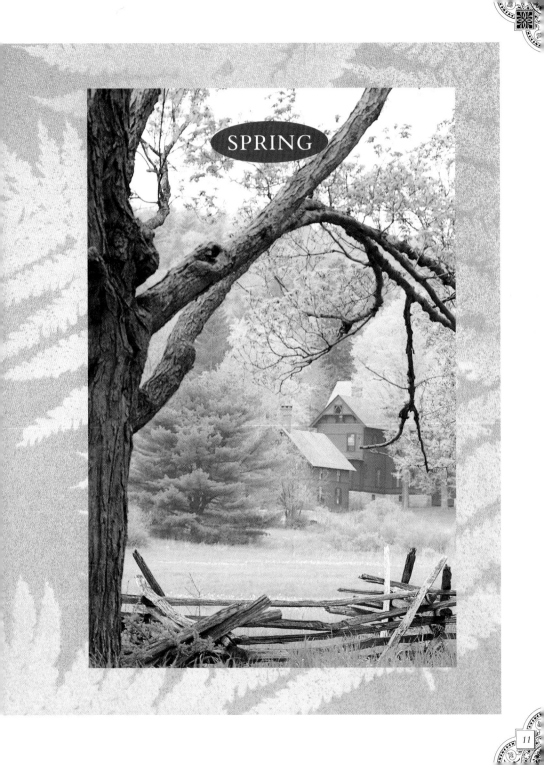

SPRING

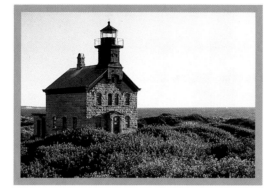

here is a sumptuous variety about the New England weather that compels the stranger's admiration—and regret. The weather is always doing something there; always attending strictly to business; always getting up new designs and trying them on people to see how they will go. But it gets through more business in spring than in any other season. In the spring I have counted one hundred and thirty-six different kinds of weather inside of twenty-four hours.

Mark Twain

F or winter's rains and ruins are over,
 And all the season of snows and sins;
The days dividing lover and lover,
The light that loses, the night that wins;
And time remembered is grief forgotten,
And frosts are slain and flowers begotten,
And in green underwood and cover
Blossom by blossom the spring begins.

Algernon Charles Swinburne

Thoughts of Spring

n our springtime every day has its hidden growth in the mind, as it has in the earth when the little folded blades are getting ready to pierce the ground.

George Eliot

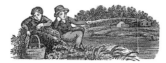

abit is habit, and not to fling out of the window by any man, but coaxed downstairs a step at a time.

Nothing so needs reforming as other people's habits.

Mark Twain

Cherished Thoughts

here, like a pillow on a bed,
 A pregnant bank swell'd up to rest
The violet's reclining head,
 Sat we two, one another's best.

John Donne

 LMOND BATH OIL

4 parts almond oil

1 part essential oil of your choice (thyme, cloves, etc.)

1 part vodka or brandy

Shake all ingredients together in a bottle. Add 1 teaspoon to each bath. The alcohol is not mandatory, but it counteracts the greasiness of the oil.

Cherished Thoughts

*R*emembering speechlessly we
seek the great forgotten language, the lost
lane-end into heaven, a stone, a leaf, an
unfound door. Where? When?

O lost, and by the wind grieved, ghost,
come back again.

Thomas Wolfe

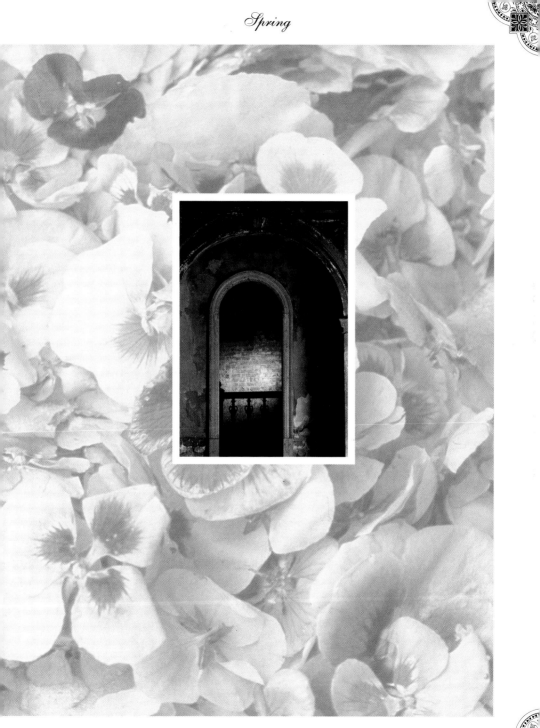

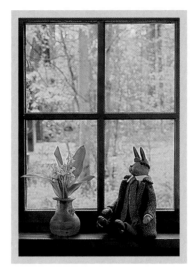

"What is REAL?" asked the Rabbit one day. "Does it mean having things that buzz inside you and a stick-out handle?"

"Real isn't how you are made," said the Skin Horse. "It's a thing that happens to you. When a child loves you for a long, long time, not just to play with, but REALLY loves you, then you become Real."

"Does it hurt?" asked the Rabbit.

"Sometimes," said the Skin Horse, for he was always truthful. "When you are Real you don't mind being hurt."

"Does it happen all at once, like being wound up," he asked, "or bit by bit?"

"It doesn't happen all at once," said the Skin Horse. "You become. It takes a long time. That's why it doesn't often happen to people who break easily, or have sharp edges, or who have to be carefully kept. Generally, by the time you are Real, most of your hair has been loved off, and your eyes drop out and you get loose in the joints and very shabby. But these things don't matter at all, because once you are Real you can't be ugly, except to people who don't understand."

Margery Williams

*Once upon a time there were four little
Rabbits, and their names were—Flopsy,
Mopsy, Cottontail, and Peter.*

Beatrix Potter

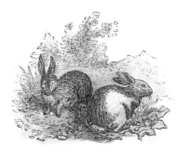

Easter Memories

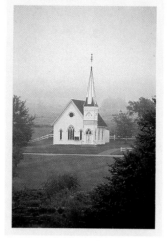

*S*pring had come once more to
Green Gables—the beautiful, carpricious,
reluctant Canadian spring, lingering along
through April and May in a succession of
sweet, fresh, chilly days, with pink
sunsets and miracles of resurrection
and growth.

L. M. Montgomery

I never saw a moor,
I never saw the sea;
Yet know I how the heather looks,
And what a billow be.

I never spoke with God,
Nor visited in heaven;
Yet certain am I of the spot
As if the checks were given.

Emily Dickinson

Special Sundays

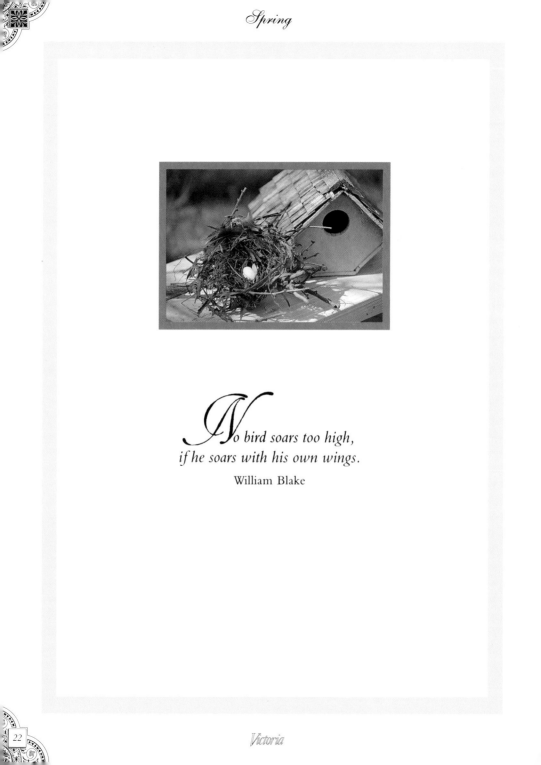

*No bird soars too high,
if he soars with his own wings.*

William Blake

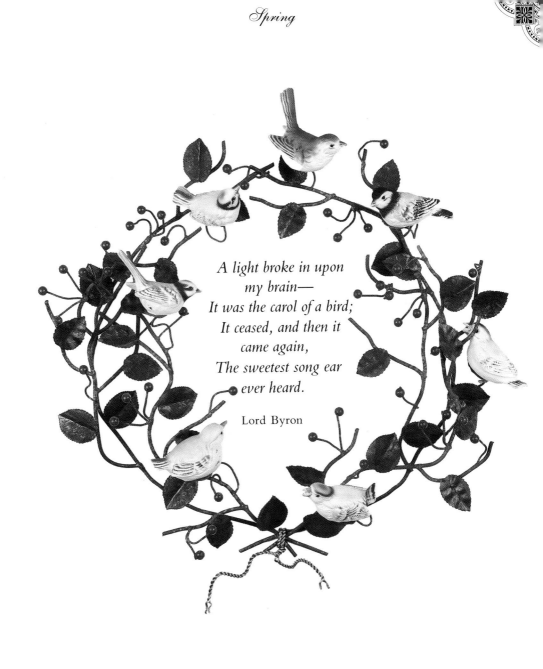

A light broke in upon
my brain—
It was the carol of a bird;
It ceased, and then it
came again,
The sweetest song ear
ever heard.

Lord Byron

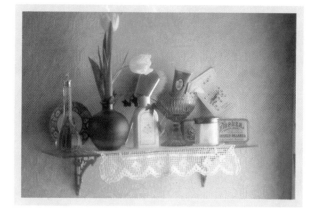

One ought, every day at least, to hear a little song, read a good poem, see a fine picture, and, if it were possible, to speak a few reasonable words.

Johann Wolfgang von Goethe

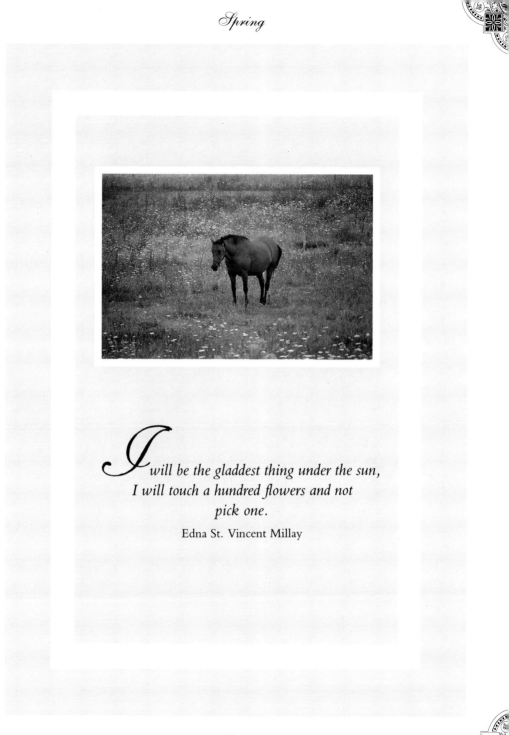

I will be the gladdest thing under the sun,
I will touch a hundred flowers and not
pick one.

Edna St. Vincent Millay

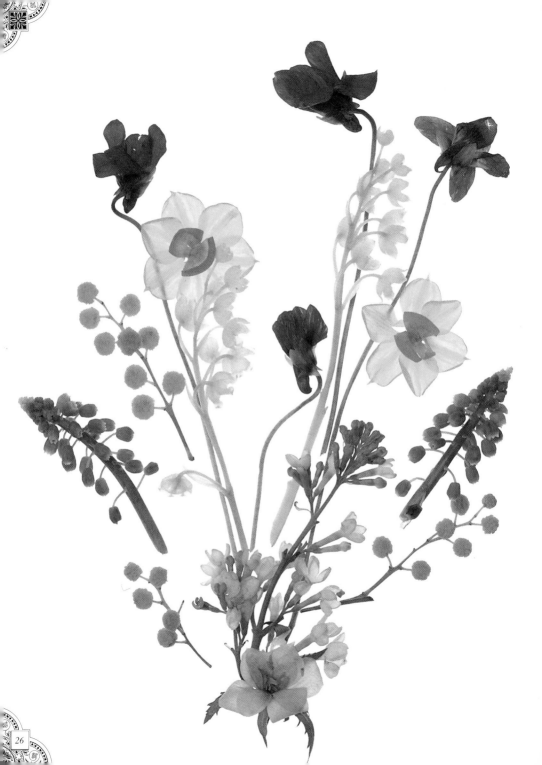

A THING OF BEAUTY

A thing of beauty is a joy forever:
Its loveliness increases; it will never
Pass into nothingness; but still will keep
A bower quiet for us, and a sleep
Full of sweet dreams, and health, and quiet breathing.
Therefore, on every morrow, are we wreathing
A flowery band to bind us to the earth,
Spite of despondence, of the inhuman dearth
Of noble natures, of the gloomy days,
Of all the unhealthy and o'er-darkened ways
Made for our searching; yes, in spite of all,
Some shape of beauty moves away the pall
From our dark spirits. Such the sun, the moon,
Trees old, and young, sprouting a shady boon
For simple sheep; and such are daffodils
With the green world they live in; and clear rills
That for themselves a cooling covert make
'Gainst the hot season; the mid-forest brake,
Rich with a sprinkling of fair musk-rose blooms:
And such too is the grandeur of the dooms
We have imagined for the mighty dead;
All lovely tales that we have heard or read:
An endless fountain of immortal drink,
Pouring unto us from the heaven's brink.

John Keats

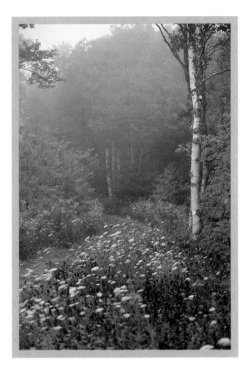

"The birch path is one of the prettiest places in the world."

It was. Other people besides Anne thought so when they stumbled on it. It was a little narrow, twisting path, winding down over a long hill straight through Mr. Bell's woods, where the light came down sifted through so many emerald screens that it was as flawless as the heart of a diamond. It was fringed in all its length with slim young birches, white-stemmed and lissom boughed; ferns and starflowers and wild lilies-of-the-valley and scarlet tufts of pigeon berries grew thickly along it; and always there was a delightful spiciness in the air and music of bird calls and the murmur and laugh of wood winds in the trees overhead.

L. M. Montgomery

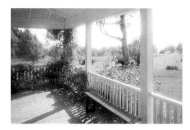

*Each friend represents a world in us, a
world possibly not born until they arrive,
and it is only by this meeting that a new
world is born.*

Anaïs Nin

Welcomed Guests

I s it so small a thing
To have enjoyed the sun,
To have lived light in the spring,
To have loved, to have thought,
 to have done;
To have advanced true friends, and
 beat down baffling foes?

Matthew Arnold

Faraway Friends

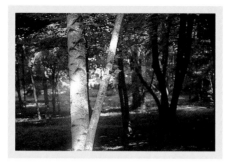

THE WEB AND THE ROCK

Autumn was kind to them, the winter was long to them—but in April, late April, all the gold sang.

Spring came that year like magic and like music and like song. One day its breath was in the air, a haunting premonition of its spirit filled the hearts of men with its transforming loveliness, working its sudden and incredible sorcery upon grey streets, grey pavements and on grey faceless tides of manswarm ciphers. It came like music faint and far, it came with triumph and a sound of singing in the air, with lutings of sweet bird cries at the break of day and the high, swift passing of a wing, and one day it was there upon the city streets with a strange, sudden cry of green, its sharp knife of wordless joy and pain.

Not the whole glory of the great plantation of the earth could have outdone the glory of the city streets that Spring. Neither the cry of great, green fields, nor the song of the hills, nor the glory of young birch trees bursting into life again along the banks of rivers, nor the oceans of bloom in the flowering orchards, the peach trees, the apple trees, the plum and cherry trees—not all of the singing and the gold of Spring, with April bursting from the earth in a million shouts of triumph, and the visible stride, the flowered feet of Springtime as it came on across the earth, could have surpassed the wordless and poignant glory of a single tree in a city street that Spring.

Thomas Wolfe

ALL THROUGH THE NIGHT

Sleep, my babe, lie still and slumber,
All through the night;
Guardian angels God will lend thee,
All through the night;
Soft and drowsy hours are creeping,
Hill and vale in slumber sleeping,
Mother dear her watch is keeping,
All through the night.

God is here, thou'lt not be lonely,
All through the night;
'Tis not I who guards thee only,
All through the night.
Night's dark shades will soon be over,
Still my watchful care shall hover,
God with me His watch is keeping,
All through the night.

Anonymous

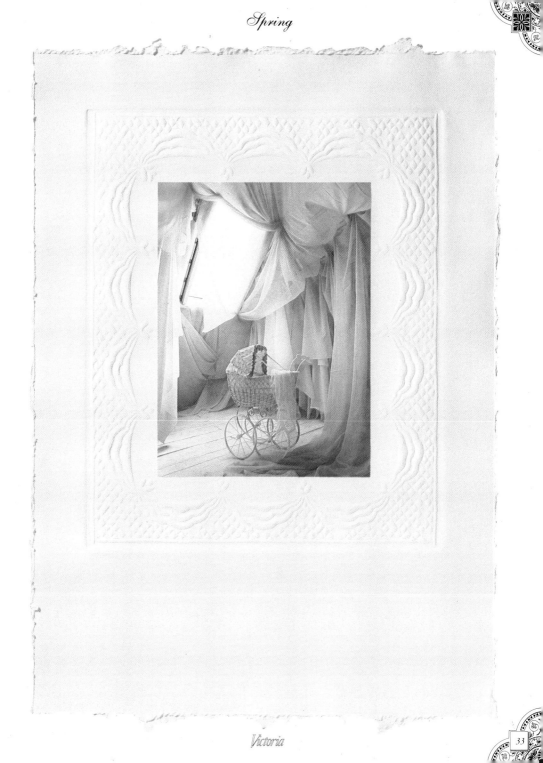

appy he
With such a mother! faith in womankind
Beats with his blood.

Alfred, Lord Tennyson

Thoughts on Mother's Day

Thou art thy mother's glass, and she
 in thee
Calls back the lovely April of her
 prime.

William Shakespeare

A mother is not a person to lean on,
but a person to make leaning
unnecessary.

Dorothy Canfield Fisher

A mother is not a person to lean on,
but a person to make leaning
unnecessary.

We can't form our children on our
own concepts; we must take them and
love them as God gives them to us.

Johann Wolfgang von Goethe

*A*h yet, ere I descend to the grave
May I a small house and a large garden have;
And a few friends, and many books, both true,
Both wise, and both delightful too!

Roger de Bussy-Rabutin

Child! Do not throw this book about;
Refrain from the unholy pleasure
Of cutting all the pictures out!
Preserve it as your chiefest treasure.

Hilaire Belloc

Literature is my Utopia. Here I am not
disfranchised. No barrier of the senses
shuts me out from the sweet, gracious
discourse of my book friends. They
talk to me without embarrassment or
awkwardness.

Helen Keller

Favorite Books

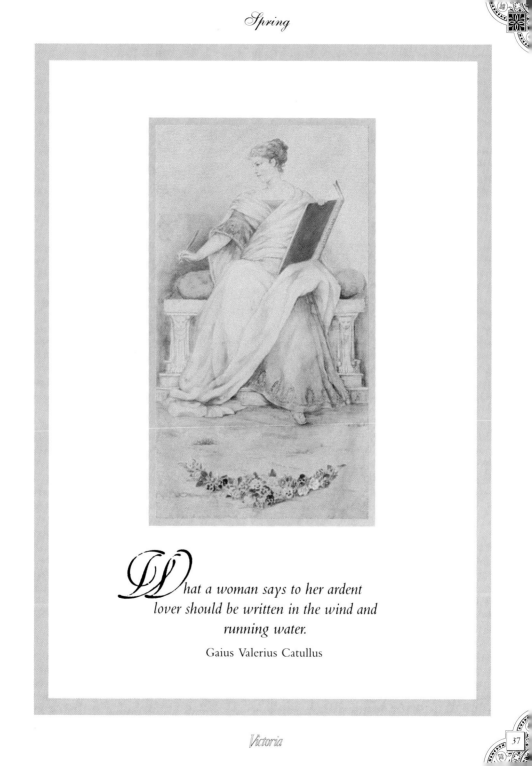

*What a woman says to her ardent
lover should be written in the wind and
running water.*

Gaius Valerius Catullus

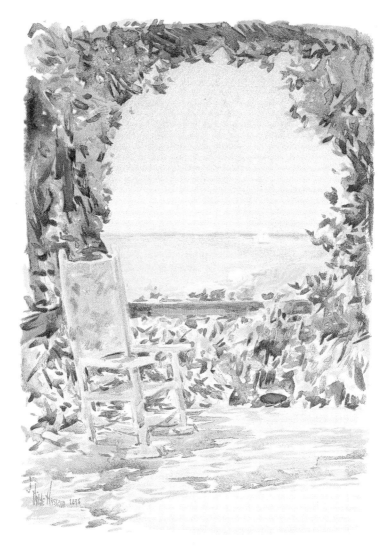

Like the musician, the painter, the poet, and the
rest, the true lover of flowers is born, not made.
And he is born to happiness in this vale of tears,
to a certain amount of the purest joy that earth can
give her children, joy that is tranquil, innocent,
uplifting, unfailing.

Celia Thaxter

*I do not know whether I was
then a man dreaming I was a butterfly, or
whether I am now a butterfly dreaming
I am a man.*

Chuang-tzu

Golden Moments

MY BETH

So the spring days came and went, the sky grew clearer, the earth greener, the flowers were up fair and early, and the birds came back in time to say good-by to Beth, who, like a tired but trustful child, clung to the hands that had led her all her life, as father and mother guided her tenderly through the Valley of the Shadow, and gave her up to God.

Seldom, except in books, do the dying utter memorable words, see visions, or depart with beatified countenances; and those who have sped many parting souls know that to most the end comes as naturally and simply as sleep. As Beth had hoped, the "tide went out easily;" and in the dark hour before the dawn, on the bosom where she had drawn her first breath, she quietly drew her last, with no farewell but one loving look, one little sigh.

With tears and prayers and tender hands, mother and sisters made her ready for the long sleep that pain would never mar again, seeing with grateful eyes the beautiful serenity that soon replaced the pathetic patience that had wrung their hearts so long, and feeling, with reverent joy, that to their darling death was a benignant angel, not a phantom full of dread.

When morning came, for the first time in many months the fire was out, Jo's place was empty, and the room was very still. But a bird sang blithely on a budding bough, close by, the snow-drops blossomed freshly at the window, and the spring sunshine streamed in like a benediction over the placid face upon the pillow—a face so full of painless peace that those who loved it best smiled through their tears, and thanked God that Beth was well at last.

Louisa May Alcott

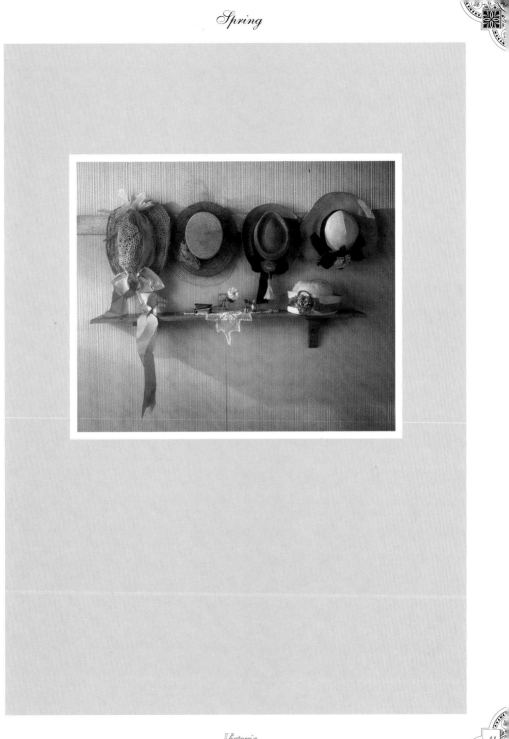

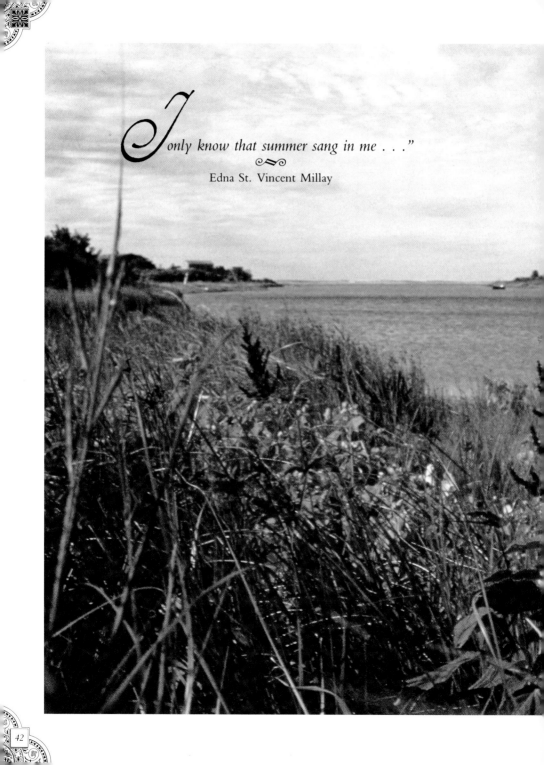

I only know that summer sang in me . . ."
Edna St. Vincent Millay

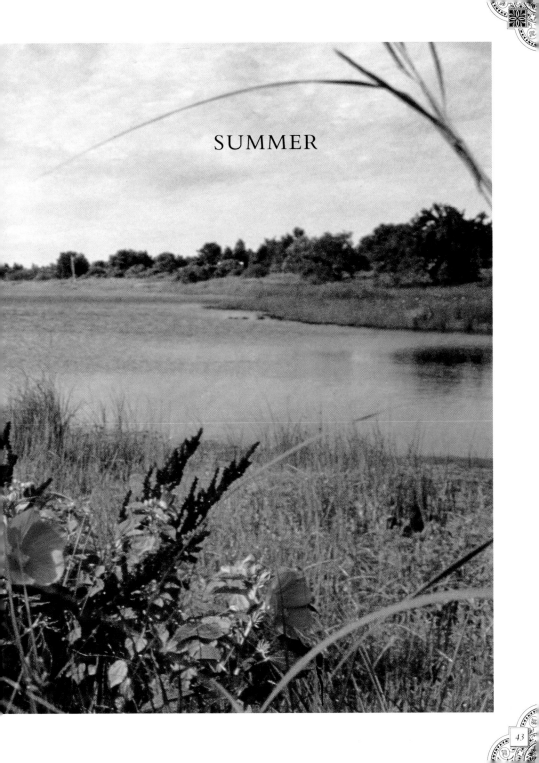

SUMMER

Why should we be in such
desperate haste to succeed, and
in such desperate enterprises? If a man
does not keep pace with his companions,
perhaps it is because he hears a
different drummer. Let him step to the
music he hears, however measured or
far away. It is not important that he
should mature as soon as an apple tree
or an oak. Shall he turn spring into
summer? If the condition of things
which we were made for is not yet, what
were any reality which we can substitute?
We will not be shipwrecked on a vain
reality. Shall we with pains erect a heaven
of blue grass over ourselves, though
when it is done we shall be sure to gaze
still at the true ethereal heaven far above,
as if the former were not?

Henry David Thoreau

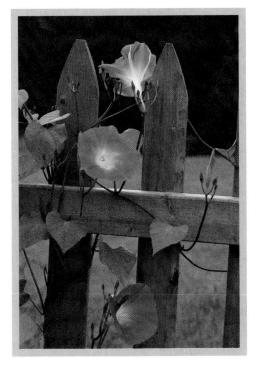

MORNING GLORY

Morning glory is the best name. It always refreshes me to see it.

Henry David Thoreau

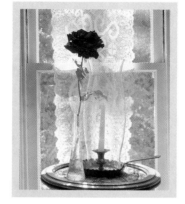

*he fact is that I did not know
how to understand anything!
I ought to have judged by the deeds and
not by words. She cast her fragrance and
her radiance over me. I ought never to
have run away from her . . . I ought to
have guessed all the affection that lay
behind her poor little stratagems. Flowers
are so inconsistent! But I was too young to
know how to love her . . . "*

Antoine de Saint-Exupéry

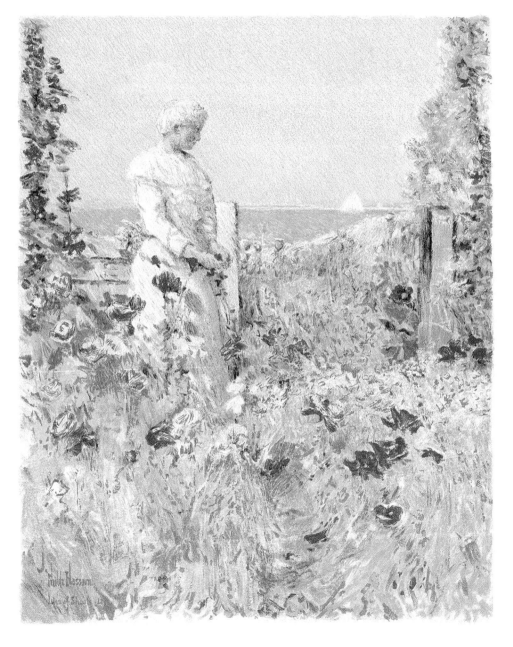

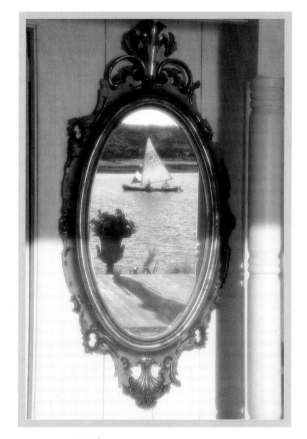

T here are two ways of spreading light:
to be the candle or the mirror that reflects it.

Edith Wharton

So we beat on, boats against the current,
borne back ceaselessly into the past.

F. Scott Fitzgerald

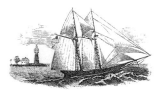

Vacations Past

Where'er you walk, cool gales shall fan
 the glade,
Trees, where you sit, shall crowd into
 a shade:
Where'er you tread, the blushing flow'rs
 shall rise,
And all things flourish where you turn
 your eyes.

Alexander Pope

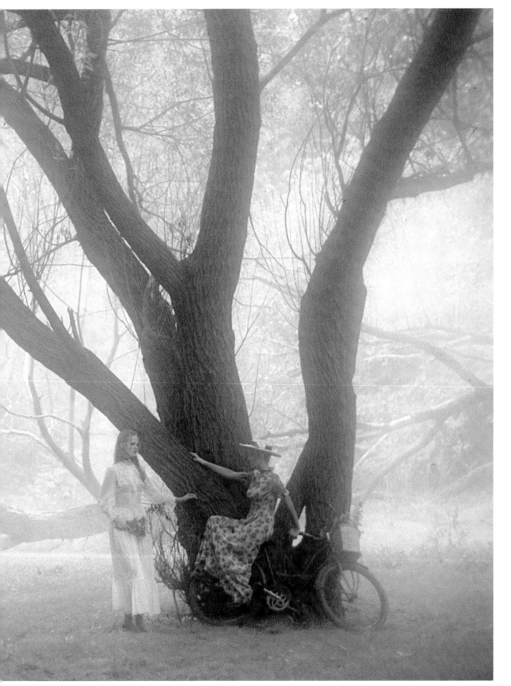

ummer afternoon—summer afternoon; to me those have always been the two most beautiful words in the English language.

Henry James

urtsy while you're thinking what to say. It saves time.

Lewis Carroll

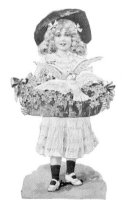

Cherished Thoughts

t is a great thing to start life with a small number of really good books which are your very own.

Sherlock Holmes

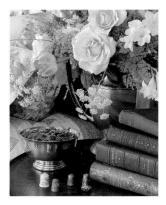

A room without books is a body without soul.

Cicero

AVENDER VINEGAR

4 cups cider vinegar

8 tablespoons lavender leaves

Heat vinegar. Pour over lavender flowers and let steep, covered, until cool. Strain and bottle. Add 1 cupful to your bath. Add 5 cups water to 1 cup vinegar for hair rinse or as an astringent for skin.

Cherished Thoughts

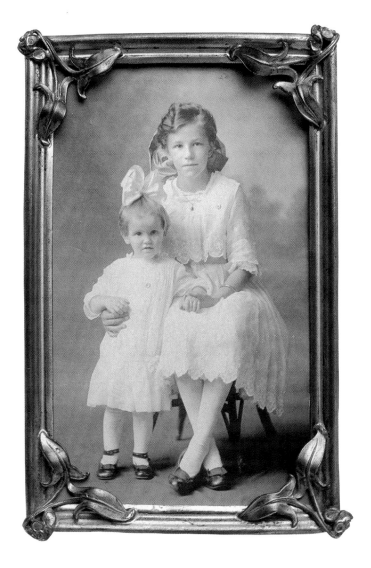

ON CHILDREN

You may give them your love but not your thoughts,
For they have their own thoughts.
You may house their bodies but not their souls,
For their souls dwell in the house of tomorrow,
which you may not visit, not even in your dreams.
You may strive to be like them,
but seek not to make them like you.
For life goes not backward nor tarries with yesterday.
You are the bows from which your children as living
arrows are sent forth.

Kahlil Gibran

"There's no use trying," she said:
"one can't believe impossible things."
"I daresay you haven't had much
practice," said the Queen. "When I was
your age, I always did it for half-an-
hour. Why, sometimes I've believed as
many as six impossible things
before breakfast."

Lewis Carroll

THE UNCULTIVATED GARDEN

The outskirt of the garden in which Tess found herself had been left uncultivated for some years, and was now damp and rank with juicy grass which sent up mists of pollen at a touch; and with tall blooming weeds emitting offensive smells—weeds whose red and yellow and purple hues formed a polychrome as dazzling as that of cultivated flowers. She went stealthily as a cat through this profusion of growth, gathering cuckoo-spittle on her skirts, cracking snails that were underfoot, staining her hands with thistle-milk and slug-slime, and rubbing off upon her naked arms sticky blights which, though snow-white on the apple-tree trunks, made madder stains on her skin; thus she drew quite near to Clare, still unobserved of him. Tess was conscious of neither time nor space. The exaltation which she had described as being producible at will by gazing at a star came now without any determination of hers; she undulated upon the thin notes of the second-hand harp, and their harmonies passed like breezes through her, bringing tears into her eyes. The floating pollen seemed to be his notes made visible, and the dampness of the garden the weeping of the garden's sensibility. Though near nightfall, the rank-smelling weed-flowers glowed as if they would not close for intentness, and the waves of colour mixed with the waves of sound.

The light which still shone was derived mainly from a large hole in the western bank of cloud; it was like a piece of day left behind by accident, dusk having closed in elsewhere.

Thomas Hardy

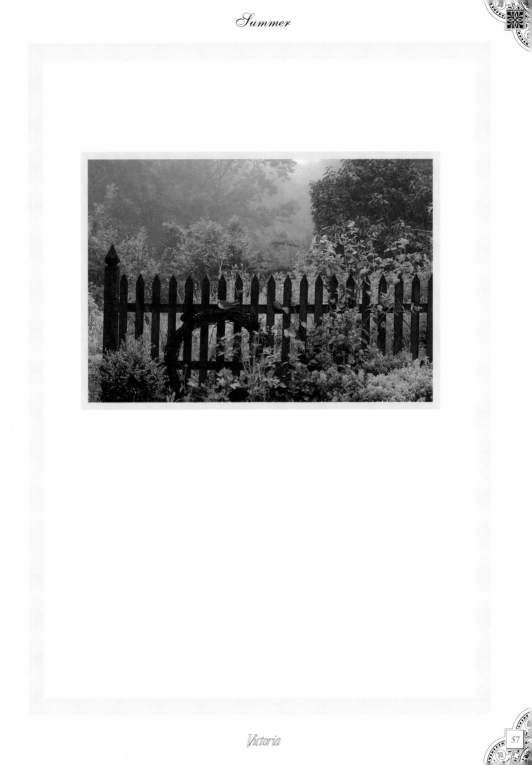

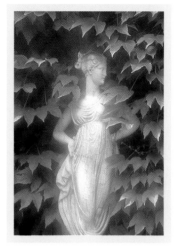

A nd the angels . . . were frozen in
hard marble silence and at a
distance life awoke, and there was a
rattle of lean wheels, a slow clangor of
shod hoofs. And he heard the whistle
wail along the river.

 Yet, as he stood for the last time by
the angels . . . he was like a man who
stands upon a hill above the town he
has left, yet he does not say "The town
is near," but turns his eyes upon the
distant soaring hills.

Thomas Wolfe

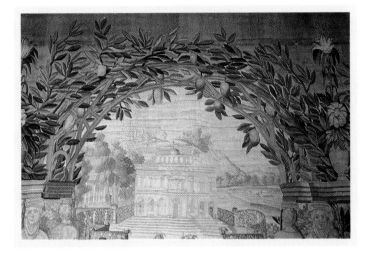

I n people's eyes, in the swing, tramp,
and trudge; in the bellow and uproar;
the carriages, motor cars, omnibuses,
vans, sandwich men shuffling and
swinging; brass bands; barrel organs; in
the triumph and the jingle and the
strange high singing of some aeroplane
overhead was what she loved; life;
London; this moment in June.

Virginia Woolf

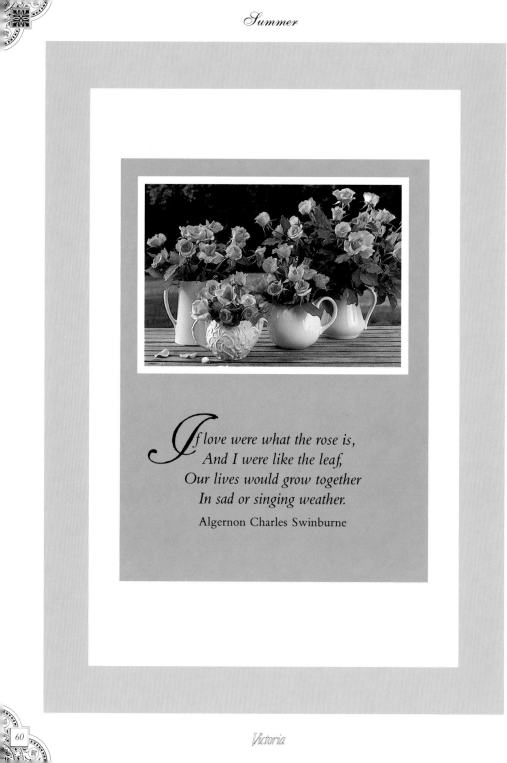

*I*f love were what the rose is,
 And I were like the leaf,
Our lives would grow together
In sad or singing weather.

Algernon Charles Swinburne

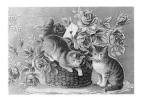

Yet Ah, that Spring should
 vanish with the Rose!
That Youth's sweet-scented manuscript
 should close!

 Edward FitzGerald

Live now, believe me,
 wait not till tomorrow;
Gather the roses of life today.

 Pierre de Ronsard

I seek a form my style
 cannot discover,
a bud of thought that
 wants to be a rose.

 Rubén Darío

What though youth gave love and roses,
Age still leaves us friends and wine.

 Thomas Moore

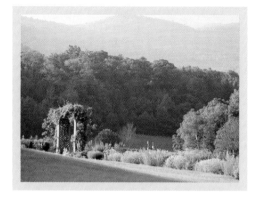

S hall I compare thee to a summer's day?
Thou art more lovely and more temperate.
Rough winds do shake the darling buds of May,
And summer's lease hath all too short a date.
Sometime too hot the eye of heaven shines,
And often is his gold complexion dimmed.
And every fair from fair sometime declines,
By chance or nature's changing course untrimmed
But thy eternal summer shall not fade,
Nor lose possession of that fair thou owest,
Nor shall Death brag thou wander'st in his shade
When in eternal lines to time thou grow'st.
 So long as men can breathe, or eyes can see,
 So long lives this, and this gives life to thee.

William Shakespeare

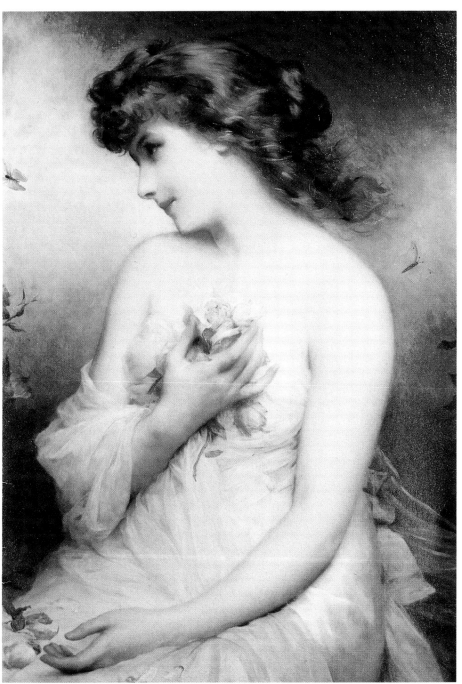

Victoria

In his younger days a man dreams of possessing the heart of a woman whom he loves; later, the feeling that he possesses the heart of a woman may be enough to make him fall in love with her.

Marcel Proust

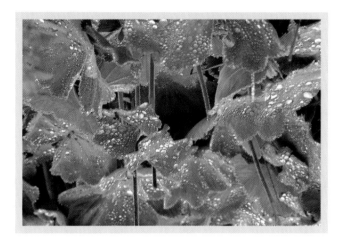

As for Emma, she didn't think she was in love with him. Love, she believed, should arrive all at once with thunder and lightning—a whirlwind from the skies that affects life, turns it every which way, wrests resolutions away like leaves, and plunges the entire heart into an abyss. She did not know that rain forms lakes on house terraces when the gutters are stopped up, and she remained secure in her ignorance until she suddenly discovered a crack in the wall.

Gustave Flaubert

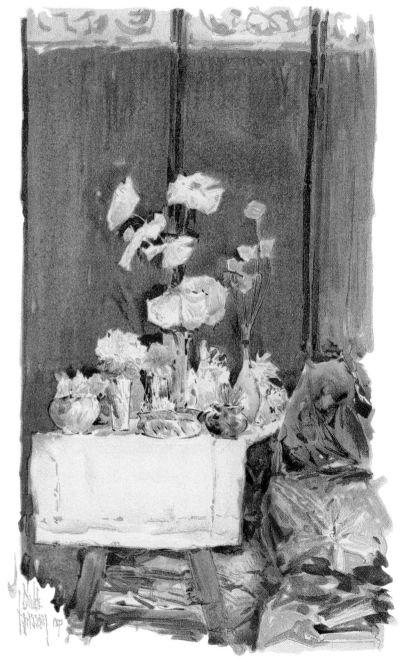

Victoria

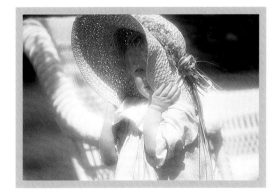

NATURE

A s a fond mother, when the day is o'er,
Leads by the hand her little child to bed,
 Half willing, half reluctant to be led,
 And leave his broken playthings on the floor.
Still gazing at them through the open door,
 Nor wholly reassured and comforted
 By promises of others in their stead,
 Which, though more splendid, may not please him more;
So Nature deals with us, and takes away
 Our playthings one by one, and by the hand
 Leads us to rest so gently, that we go
Scarce knowing if we wish to go or stay,
 Being too full of sleep to understand
 How far the unknown transcends the what we know.

Henry Wadsworth Longfellow

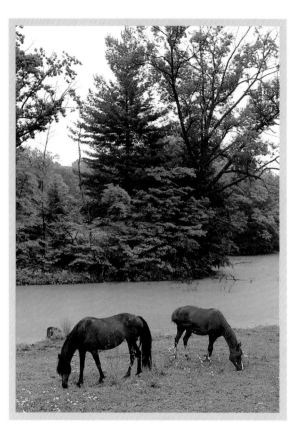

Whe all the world is young, lad,
 And all the trees are green;
And every goose a swan, lad,
And every lass a queen;
Then hey for boot and horse, lad,
And round the world away:
Young blood must have its course, lad,
And every dog his day.

Charles Kingsley

I believe a leaf of grass is no less than the journey-work of the stars.

Walt Whitman

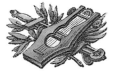

Summer Joys

THERE IS A GARDEN IN HER FACE

There is a garden in her face,
Where roses and white lilies grow;
A heav'nly paradise is that place
Wherein all pleasant fruits do flow.
There cherries grow which none may buy
Till cherry-ripe themselves do cry.

Those cherries fairly do enclose
Of orient pearl a double row,
Which when her lovely laughter shows,
They look like rosebuds filled with snow.
Yet them nor peer nor prince can buy,
Till cherry-ripe themselves do cry.

Her eyes like angels watch them still;
Her brows like bended bows do stand,
Threat'ning with piercing frowns to kill
All that attempt with eye or hand
Those sacred cherries to come nigh,
Till cherry-ripe themselves do cry.

Thomas Campion

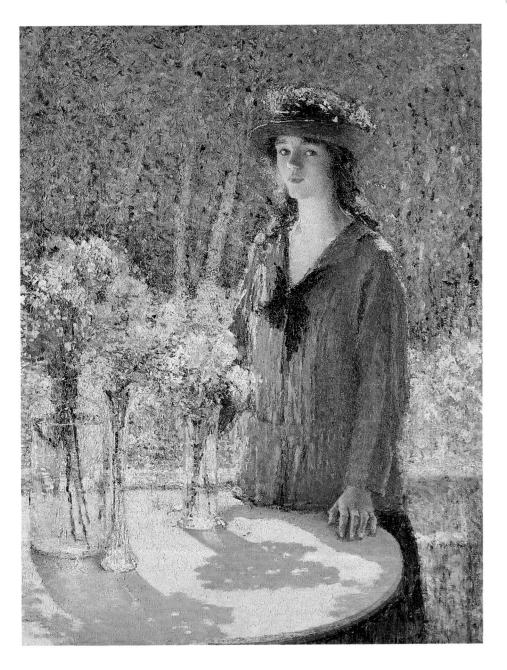

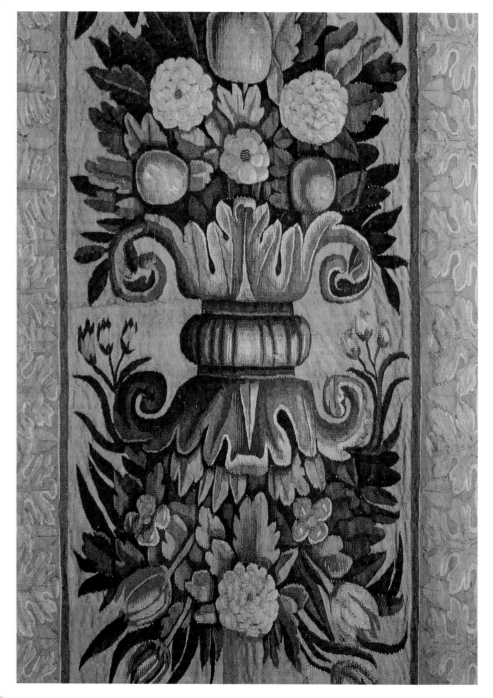

THE SUN RISING

B usy old fool, unruly sun,
 Why dost thou thus
Through windows and through curtains call on us?
Must to thy motions lovers' seasons run?
 Saucy, pedantic wretch, go chide
 Late schoolboys and sour prentices,
 Go tell court huntsmen that the king will ride,
 Call country ants to harvest offices.
Love, all alike, no season knows nor clime,
Nor hours, days, months, which are the rags of time.

John Donne

I have been here before,
But when or how I cannot tell;
I know the grass beyond the door,
The sweet keen smell,
The sighing sound, the lights
around the shore.

Dante Gabriel Rossetti

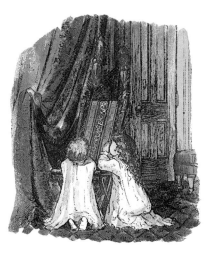

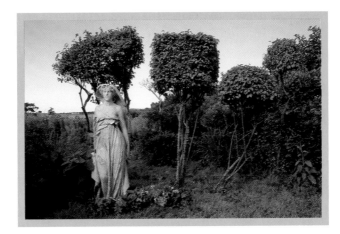

EPITAPH

arm summer sun, shine kindly here;
Warm southern wind, blow softly here;
Green sod above, lie light, lie light—
Good-night, dear heart, good-night, good-night.

Mark Twain

Written for his daughter, Olivia Susan Clemens,
who died August 18, 1896, aged 24.

Come, ye thankful people, come,
Raise the song of Harvest-home;
All is safely gathered in,
Ere the winter storms begin.

～

Henry Alford

AUTUMN

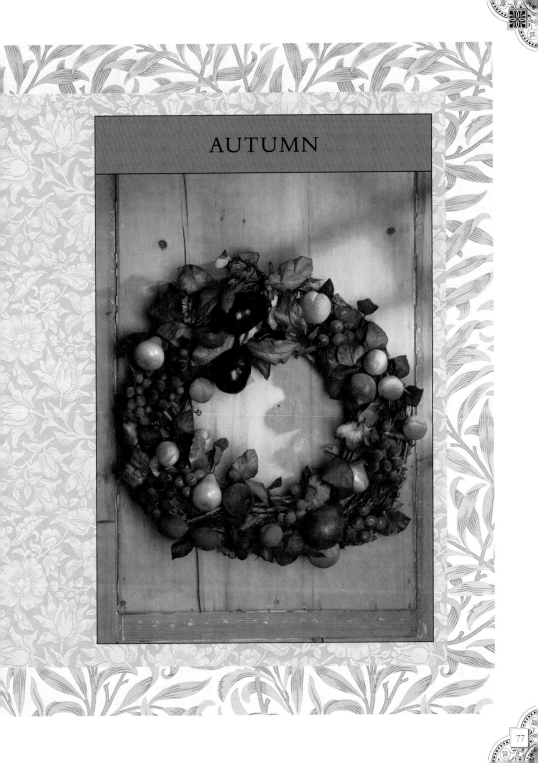

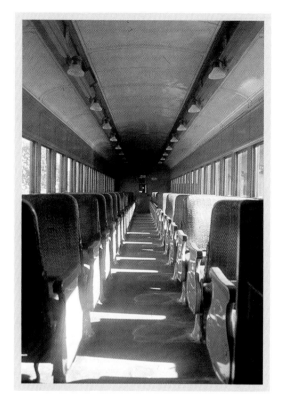

My heart is warm with the friends I make,
And better friends I'll not be knowing;
Yet there isn't a train I wouldn't take,
No matter where it's going.

Edna St. Vincent Millay

A journey is a person in itself;
no two are alike, and all plans,
safeguards, policing and coercion are fruitless.
We find after years of struggle
that we do not take a trip;
a trip takes us.

John Steinbeck

Travels Remembered

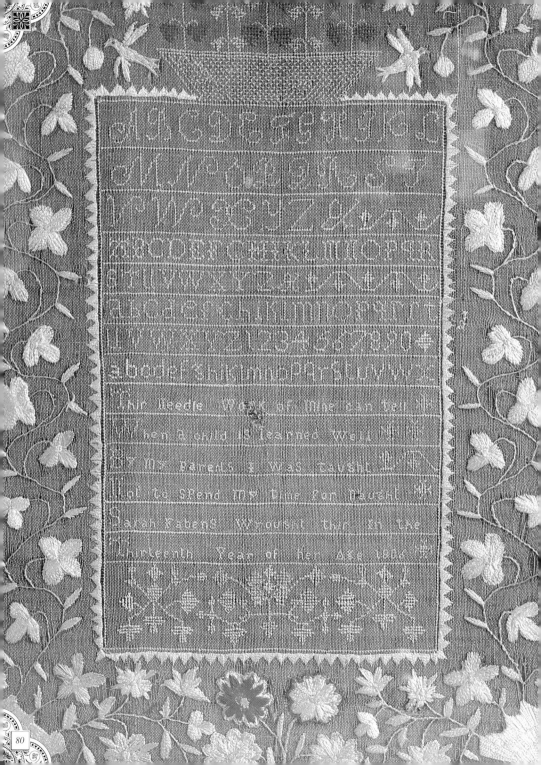

SCHOOL DAYS PAST

"School Days, school days/Dear old golden rule days days/Readin' and 'ritin' and 'rithmetic,/Taught to the tune of the hick'ry stick . . ."

How well I remember that poignant little waltz my mother taught me. To this day it evokes not just my school days, but what I imagine hers were like in the 1930s. "You were my queen in calico . . ." went the words: Calico, now where was that? I pictured some better place, with warm 1930s sunlight and wide open fields, sort of Oz-like; my beautiful queen in calico would have been any of the girls I was in love with in first grade.

School-Days (Or When We Were a Couple of Kids)—the song's full title—must have moved people similarly when it was first published in 1907 for it promptly sold over three million copies. Even then, nostalgia was surely in the air. "Let's take a trip/On memory's ship," goes the first verse, "Back to the bygone days." What memories could have stirred those denizens of 1907? How ironic that *their* present—the now bygone days of the turn-of-the-century—seems so idyllic to us today!

But then that is why this song is truly timeless; it addresses our perennial longing for lost innocence, reminding us to look back and remember what it was like when we were a couple of kids.

Richard Horn

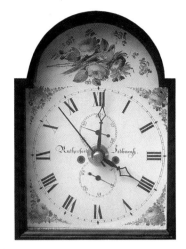

In our house on North Congress Street in Jackson, Mississippi, where I was born, the oldest of three children, in 1909, we grew up to the striking of clocks. There was a mission-style oak grandfather clock standing in the hall, which sent its gong-like strokes through the livingroom, diningroom, kitchen and pantry, and up the sounding board of the stairwell. Through the night, it could find its way to our ears; sometimes, even on the sleeping porch, midnight could wake us up. My parents' bedroom had a smaller striking clock that answered it. Though the kitchen clock did nothing but show the time, the diningroom clock was a cuckoo clock with weights on long chains, on one of which my baby brother, after climbing on a chair to the top of the china closet, once succeeded in suspending the cat for a moment. I don't know whether or not my father's Ohio family, in having been Swiss back in the 1700s before the first three Welty brothers came to America, had anything to do with this; but we all of us have been time-minded in our lives. This was good at least for a future fiction writer, being able to learn so penetratingly, and almost first of all, about chronology. It was one of a good many things I learned almost without knowing it; it would be there when I needed it.

Eudora Welty

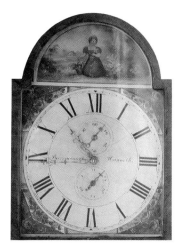

Idle Hours

*W*hen I play with my cat, who knows
if I am not a pastime to her more than she
is to me?

Michel Eyquem de Montaigne

He prayeth best who loveth best
All things both great and small;
For the dear God who loveth us,
He made and loveth all.

Samuel Taylor Coleridge

One of the most striking differences
between a cat and a lie is that a cat has
only nine lives.

Mark Twain

Beloved Pets

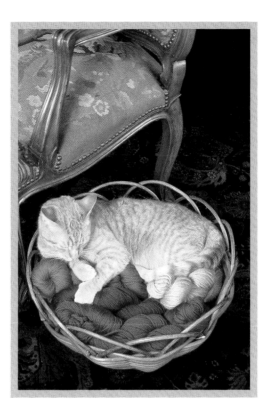

Autumn. The back doors shut because of
the heating; dirt boxes brought in to the
veranda; cats let out when they ask to be.
Not very often: they seem happy enough
with an indoors existence
when it is cold.

Doris Lessing

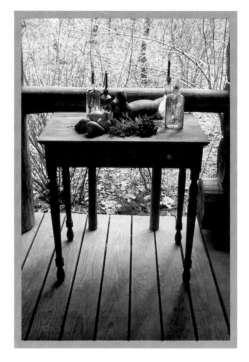

I saw old Autumn in the misty morn
Stand shadowless like silence, listening
To silence.

Thomas Hood

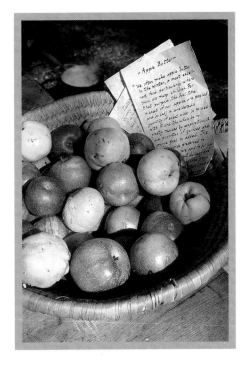

And pluck till time and times are done
The silver apples of the moon,
The golden apples of the sun.

William Butler Yeats

The days of declining autumn which followed her assent, beginning with the month of October, formed a season through which she lived in spiritual altitudes more nearly approaching ecstasy than any other period of her life. There was hardly a touch of earth in her love for Clare. To her sublime trustfulness he was all that goodness could be—knew all that a guide, philosopher, and friend should know. She thought every line in the contour of his person the perfection of masculine beauty, his soul the soul of a saint, his intellect that of a seer. The wisdom of her love for him, as love, sustained her dignity; she seemed to be wearing a crown. The compassion of his love for her, as she saw it, made her lift up her heart to him in devotion. He would sometimes catch her large, worshipful eyes, that had no bottom to them, looking at him from their depths, as if she saw something immortal before her.

She dismissed the past—trod upon it and put it out, as one treads on a coal that is smouldering and dangerous.

She had not known that men could be so disinterested, chivalrous, protective, in their love for women as he. Angel Clare was far from all that she thought him in this respect; absurdly far, indeed; but he was, in truth, more spiritual than animal; he had himself well in hand, and was singularly free from grossness. Though not cold-natured, he was rather bright than hot—less Byronic than Shelleyan; could love desperately, but with a love more especially inclined to the imaginative and ethereal; it was a fastidious emotion which could jealously guard the loved one against his very self. This amazed

and enraptured Tess, whose slight experiences had been so infelicitous till now; and in her reaction from indignation against the male sex she swerved to excess of honour for Clare.

They unaffectedly sought each other's company; in her honest faith she did not disguise her desire to be with him. The sum of her instincts on this matter, if clearly stated, would have been that the elusive quality in her sex which attracts men in general might be distasteful to so perfect a man after an avowal of love, since it must in its very nature carry with it a suspicion of art.

The country custom of unreserved comradeship out-of-doors during betrothal was the only custom she knew, and to her it had no strangeness; though it seemed oddly anticipative to Clare till he saw how normal a thing she, in common with all the other dairy-folk, regarded it. Thus, during this October month of wonderful afternoons they roved along the meads by creeping paths which followed the brinks of trickling tributary brooks, hopping across by little wooden bridges to the other side, and back again. They were never out of the sound of some purring weir, whose buzz accompanied their own murmuring, while the beams of the sun, almost as horizontal as the mead itself, formed a pollen of radiance over the landscape. They saw tiny blue fogs in the shadows of trees and hedges, all the time that there was bright sunshine elsewhere. The sun was so near the ground, and the sward so flat, that the shadows of Clare and Tess would stretch a quarter of a mile ahead of them, like two long fingers pointing afar to where the green alluvial reaches abutted against the sloping sides of the vale.

Thomas Hardy

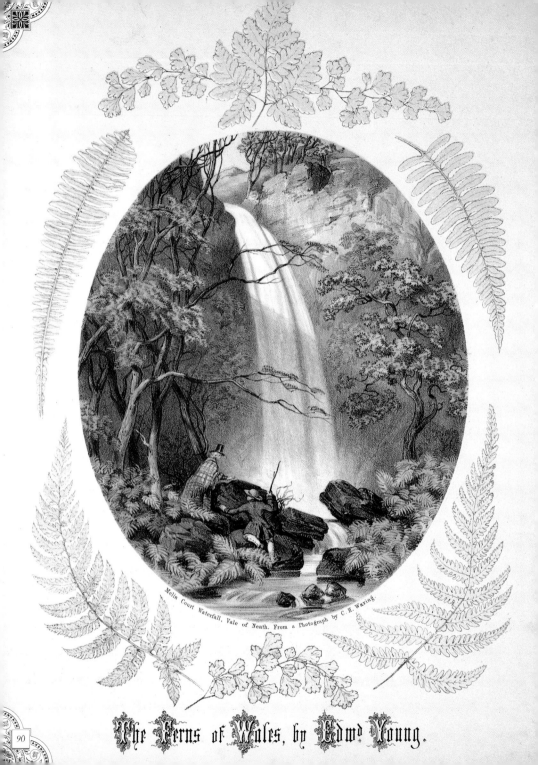

Melin Court Waterfall, Vale of Neath. From a Photograph by C. H. Waring.

The Ferns of Wales, by Edwᵈ Young.

90

"My name is Margalo," said the bird,
softly, in a musical voice.
"I come from fields once tall with wheat,
from pastures deep in fern and thistle;
I come from vales of meadowsweet,
and I love to whistle."

E.B. White

Thoughts for an Autumn Afternoon

o spring, nor summer beauty
 hath such grace,
As I have seen in one autumnal face.

John Donne

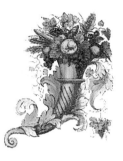

he day becomes more solemn
 and serene
 When noon is past—there is a harmony
 In autumn, and a luster in its sky,
Which through the summer is not heard
 or seen,
As if it could not be, as if it had not been!

Percy Bysshe Shelley

ERBAL VINEGARS

*Several sprigs of fresh rosemary, basil, or
tarragon*

Or: a tablespoon of green peppercorns

Or: 4 or 5 cloves of garlic

Or: 3 or 4 chili peppers

Or a combination of any of the above

4 cups good-quality white-wine vinegar

⅓ cup sugar

*Place herbs in a 5-cup jar or bottle. Heat
the vinegar and sugar together until the
sugar dissolves. Pour into the jar. Seal
tightly and set aside in a cool, dark place for
at least 2 weeks. Strain before using.*
Yield: 5 cups.

Cherished Thoughts

Drying flowers and herbs is a simple affair and requires only a gentle touch and some patience. To hang dry, strip the first few inches or so of the stems and tie the flowers together with a cotton string, using the end of the string to hang the bunch from a rafter, clothesline, or peg. You may want to slip a rubberband around the stems as well, in case they shrink so much in drying they slip out of the string.

If the drying room is not warm enough, flowers will lose their color, and if bunches are too big or hung too close together, the flowers will misshapen and air will not

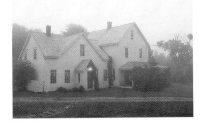

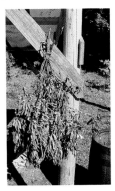

circulate among the blossoms. You may want to experiment with drying places by hanging similar bunches in different rooms at the same time, and then compare drying times and color preservation later.

oldly, sadly descends
The autumn evening. The field
Strewn with its dank yellow drifts
Of withered leaves, and the elms,
Fade into dimness apace,
Silent; hardly a shout
From a few boys late at their play!

Matthew Arnold

Cherished Thoughts

O, it sets my heart a-clickin'
like the tickin' of a clock,
When the frost is on the punkin
and the fodder's in the shock.

James Whitcomb Riley

⁓

Listen! the wind is rising,
and the air is wild with leaves,
We have had our summer evenings,
now for October eves!

Humbert Wolfe

CURLYLOCKS

Curlylocks, Curlylocks,
Wilt thou be mine?
Thou shalt not wash dishes
Nor yet feed the swine,
But sit on a cushion
And sew a fine seam,
And feed upon strawberries,
Sugar and cream.

Anonymous

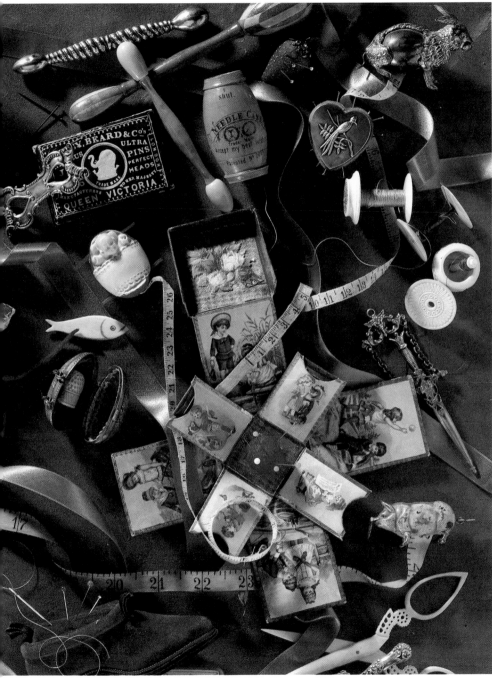

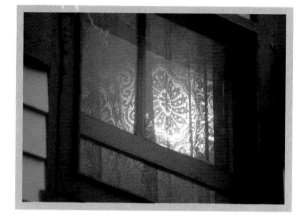

The room was a pleasant one, at the top of the house, overlooking the sea, on which the moon was shining brilliantly. After I said my prayers, and the candle had burnt out, I remember how I still sat looking at the moonlight on the water, as if I could hope to read my fortune in it, as in a bright book; or to see my mother with her child, coming from heaven, along that shining path, to look upon me as she had looked when I last saw her sweet face. I remember how the solid feeling with which at length I turned my eyes away, yielded to the sensation of gratitude and rest which the sight of the white-curtained bed—and how much more the lying softly down upon it, nestling in the snow white sheets!—inspired. I remember how I thought of all the solitary places under the night sky where I had slept, and how I prayed that I might never be houseless any more and never might forget the houseless. I remember how I seemed to float, then, down the melancholy glory of that track upon the sea, away into the world of dreams.

Charles Dickens

This life's dim windows of the soul
Distorts the heavens from pole to pole
And leads you to believe a lie
When you see with, not through, the eye.

William Blake

Family Treasures

*F*ool!" said my muse to me, "look in thy
heart, and write."

Sir Philip Sidney

I have made this letter longer than usual,
 because I lack the time to make it shorter.

Blaise Pascal

I pray you, in your letters,
When you shall these unlucky deeds relate,
Speak of me as I am; nothing extenuate,
Nor set down aught in malice: then, must you speak
Of one that loves not wisely but too well.

William Shakespeare

She'll wish there was more,
 and that's the great art o' letter-writin'.

Charles Dickens

Dear Friends

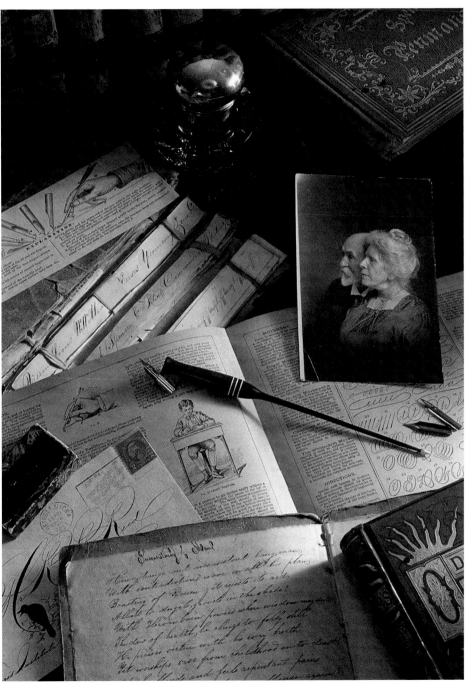

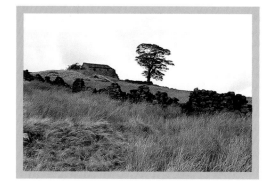

I lingered round them, under that benign sky; watched the moths fluttering among the heath and harebells; listened to the soft wind breathing through the grass; and wondered how anyone could ever imagine unquiet slumber for the sleepers in that quiet earth.

Emily Brontë

*I like trees because they seem more
resigned to the way they have to live than
other things do.*

Willa Cather

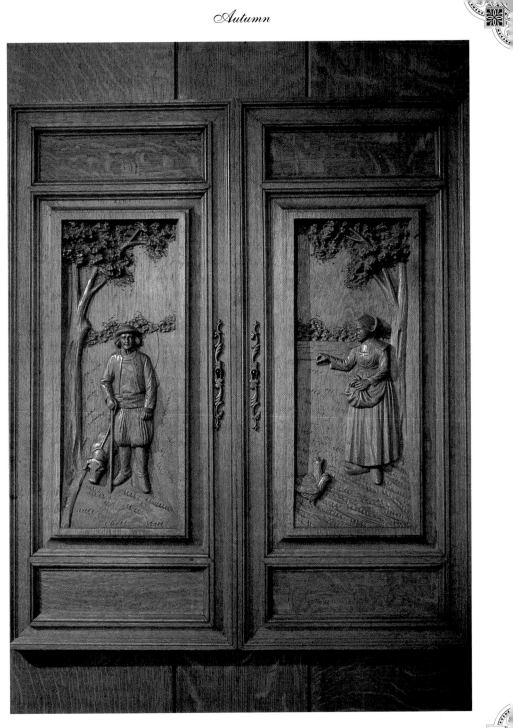

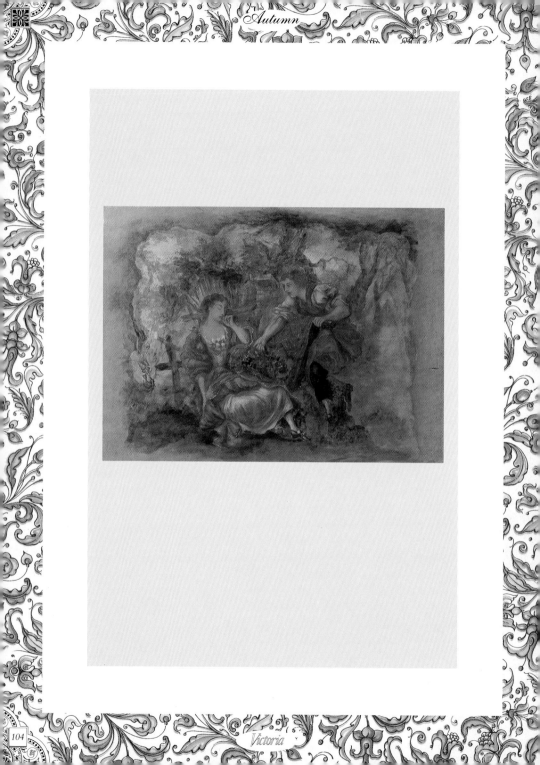

Go from me. Yet I feel that I shall stand
Henceforward in thy shadow. Nevermore
Alone upon the threshold of my door
Of individual life, I shall command
The uses of my soul, nor lift my hand
Serenely in the sunshine as before,
Without the sense of that which I forbore—
Thy touch upon the palm. The widest land
Doom takes to part us, leaves thy heart in mine
With pulses that beat double. What I do
And what I dream include thee, as the wine
Must taste of its own grapes. And when I sue
God for myself, He hears that name of thine,
And sees within my eyes the tears of two.

Elizabeth Barrett Browning

I think I could turn and live with animals,
they are so placid and self-contained . . .
They do not sweat and whine about their condition,
They do not lie awake in the dark and weep
for their sins. . .
Not one is dissatisfied, not one is demented with the mania of
owning things. . .

Walt Whitman

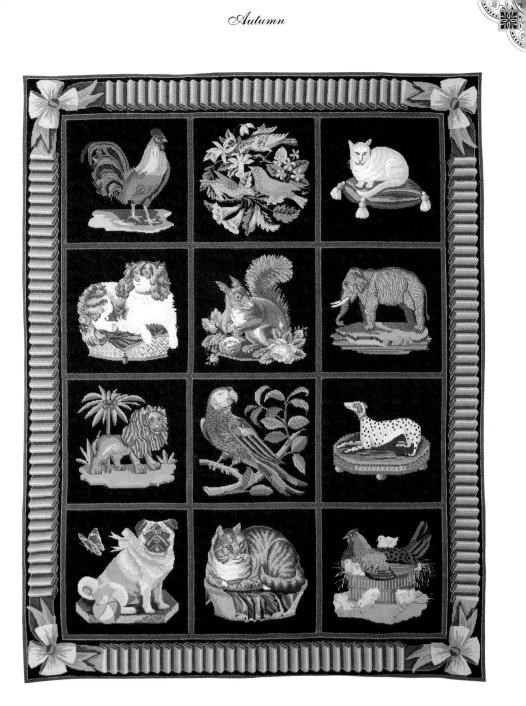

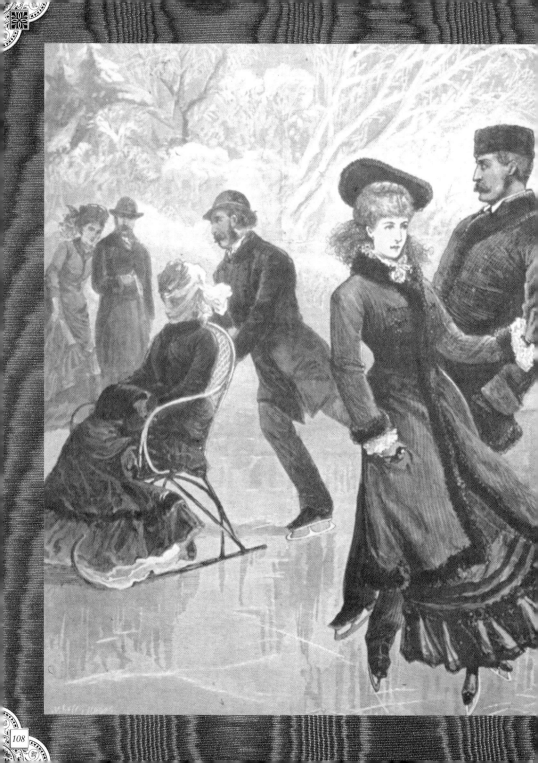

WINTER

*There's a certain Slant of light,
Winter Afternoons—*

Emily Dickinson

REMEMBERING CHRISTMAS 1902

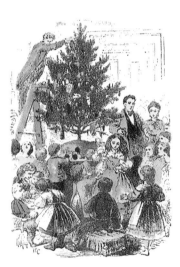

John Ellsworth Walton, Uncle Ed, the only son in the family, was an adventurer, not unlike his father, who at 16 joined the Grand Army of the Republic after drinking many glasses of water to weigh enough for enlistment. After the Civil War, great-great-grandfather Walton returned to Iowa to farm. Family lore had it he always maintained a twinkle in his eye, and on good days, even as an old man, he strolled the streets of downtown Redfield, his six-foot frame as straight as a ramrod, his GAR hat placed squarely upon his head.

Uncle Ed left his more timid and traditional sisters behind and "ran off" to Chicago. And he did come upon good fortune. His good nature must have been appreciated by his staff because in 1902, at Christmastime, they presented him with a silver and ruby pitcher. I've seen it shined up for many Christmases, and along with the polish, the luster of Uncle Ed and the happiness of holidays in Redfield.

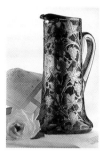

The Walton children always came home for Christmas. Some from Des Moines and, of course, Uncle Ed from Illinois. The train stopped in Redfield in those days and Robert Richardson Walton met his kin at the station with horse and carriage. They say the neighbors always knew when they heard the sleighbells that Rosa Walton and her children had arrived. I can imagine them all—white fur rimming the bonnets of the little girls clad in their best velvet coats. Quilts and blankets snugged tightly around everyone on the snowy trip to the farm. Those sleigh bells are still a part of our family holidays, and the very sound of them puts me amongst people I only know through legends, or adults whose childhoods are like fairy tales to me.

Hampers of food—smoked turkey and fresh oysters—arrived with Uncle Ed. Truly these were delicacies to Iowa farmers. And there were wondrous presents for everyone. Aunt Freda, the most phenomenal needleworker anyone had ever known, brought her gifts—beautiful pieces of handwork so precise they seemed to have been wrought by an angel.

The Iowa prairie can be a forbidding place in late December. I envision that white Victorian farmhouse in a swirl of snow, and I feel the biting wind. But inside, there is a family together—its prodigal son returned, and with him the welcome gift of warm-heartedness.

It takes so little imagination to journey again to a happy time, even one we did not really experience. This stately silver pitcher bespeaks a Walton family Christmas—1902, it seems like yesterday to me, and I wonder again at those tales. I see Uncle Ed, looking just like his photograph in the family album, standing erect in a fur-collared coat and holding a black hat. Surely that is what he wore as he carried his Christmas baskets—heavy with treasure—into the house in Redfield, God blessing everyone.

Jenny Walton

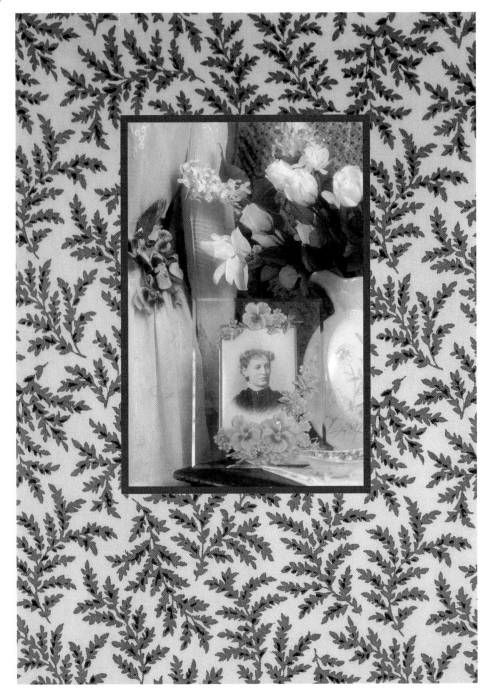

*It is easy in the world
to live after the world's opinion;
it is easy in solitude
to live after our own;
but the great man is he who
in the midst of the crowd
keeps with perfect sweetness
the independence
of solitude.*

Ralph Waldo Emerson

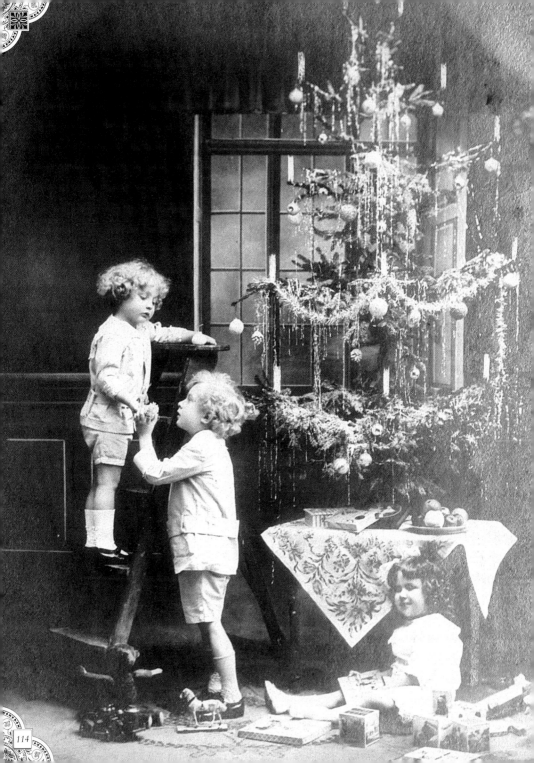

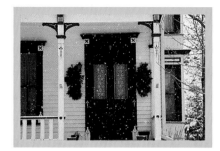

One Christmas was so much like
another, in those years around
the seatown corner now and out of all
sound except the distant speaking of the
voices I sometimes hear a moment
before sleep, that I can never remember
whether it snowed for six days and six
nights when I was twelve or whether it
snowed for twelve days and twelve
nights when I was six.

Dylan Thomas

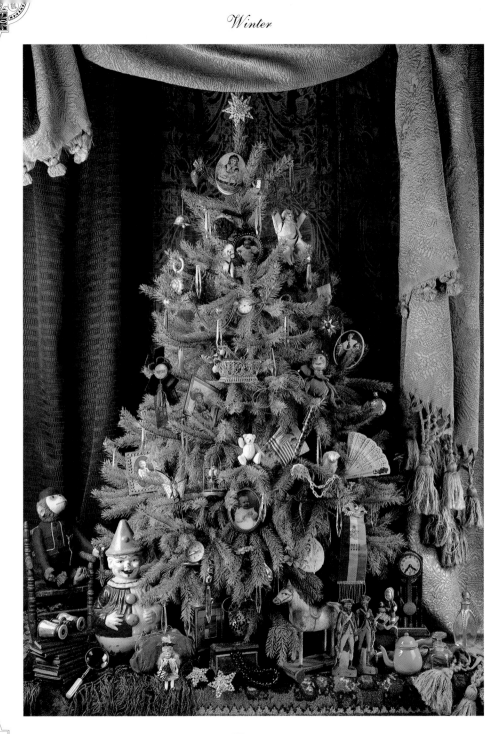

Christmas Memories

S crooge was better than his word. He did it all, and infinitely more; and to Tiny Tim, who did NOT die, he was a second father. He became as good a friend, as good a master, and as good a man, as the good old city knew, or any other good old city, town, or borough, in the good old world. Some people laughed to see the alteration in him, but he let them laugh, and little heeded them; for he was wise enough to know that nothing ever happened on this globe, for good, at which some people did not have their fill of laughter in the outset; and knowing that such as these would be blind anyway, he thought it quite as well that they should wrinkle up their eyes in grins, as have the malady in less attractive forms. His own heart laughed; and that was quite enough for him . . . and it was always said of him, that he knew how to keep Christmas well, if any man alive possessed the knowledge. May that be truly said of us, and all of us! And so, as Tiny Tim observed, God Bless Us, Every One!

Charles Dickens

Thoughts for the New Year

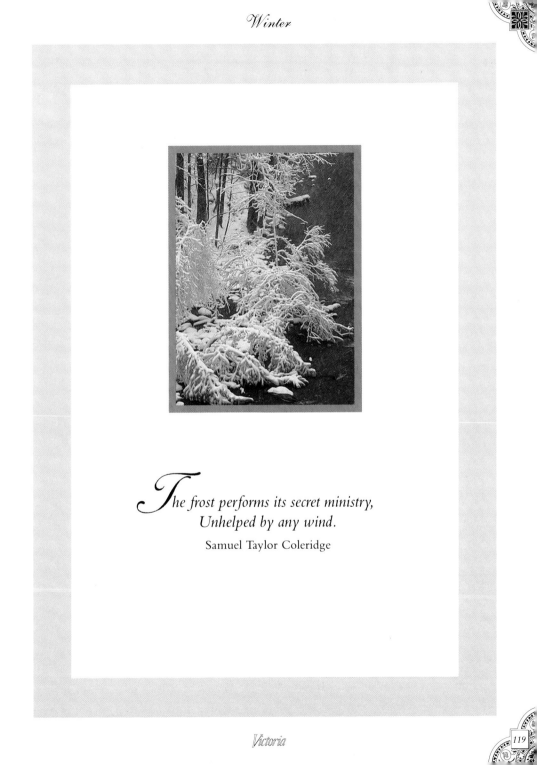

The frost performs its secret ministry,
Unhelped by any wind.

Samuel Taylor Coleridge

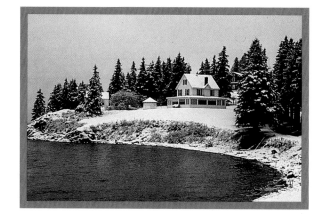

S hut in from all the world without,
We sat the clean-winged hearth about
Content to let the north-wind roar
In baffled rage at pane and door,
While the red logs before us beat
The frost-line back with tropic heat;
And ever, when a louder blast
Shook beam and rafter as it passed,
The merrier up its roaring draught
The great throat of the chimney laughed;

The house-dog on his paws outspread
Laid to the fire his drowsy head,
The cat's dark silhouette on the wall
A couchant tiger's seemed to fall;
And, for the winter fireside meet,
Between the andirons' straddling feet,
The mug of cider simmered slow,
The apples sputtered in a row,
And, close at hand, the basket stood
With nuts from brown October's wood.

John Greenleaf Whittier

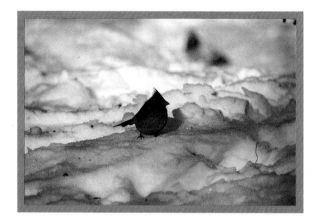

And birds sit brooding
in the snow . . .

William Shakespeare

I have now been married ten years. I know what it is to live entirely for and with what I love best on earth. I hold myself supremely blest—blest beyond what language can express; because I am my husband's life as fully as he is mine. No woman was ever nearer to her mate than I am: ever more absolutely bone of his bone and flesh of his flesh. . . . We talk, I believe, all day long; to talk to each other is but a more animated and an audible thinking. All my confidence is bestowed upon him, all his confidence is devoted to me; we are precisely suited in character— perfect concord is the result.

Charlotte Brontë

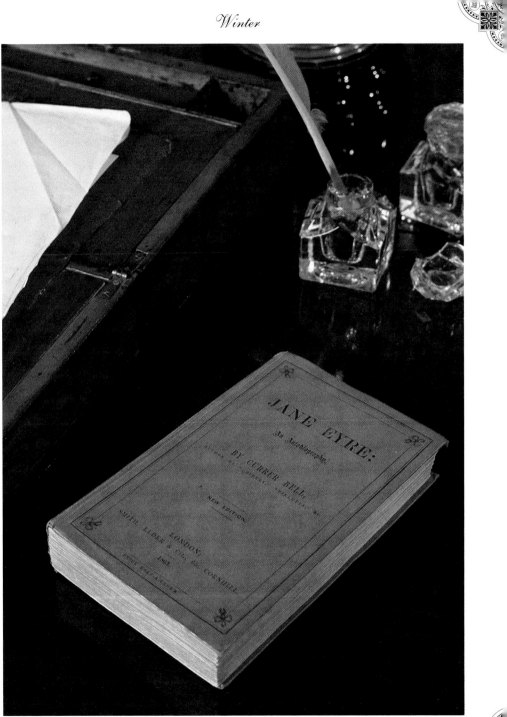

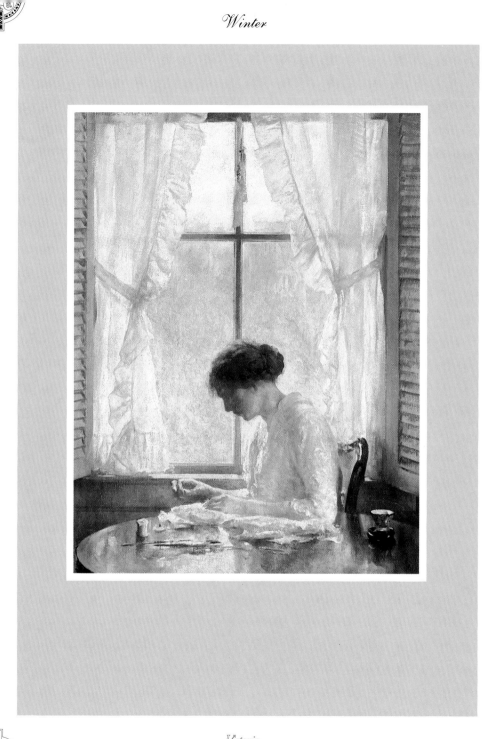

SEWING A DRESS

The need
these closed-in days

to move before you
smooth-draped
color-elated

in a favorable wind

Lorine Niedecker

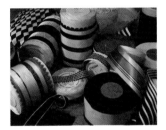

Lucy Locket lost her pocket,
Kitty Fisher found it;
There was not a penny in it,
But a ribbon round it.

Anonymous

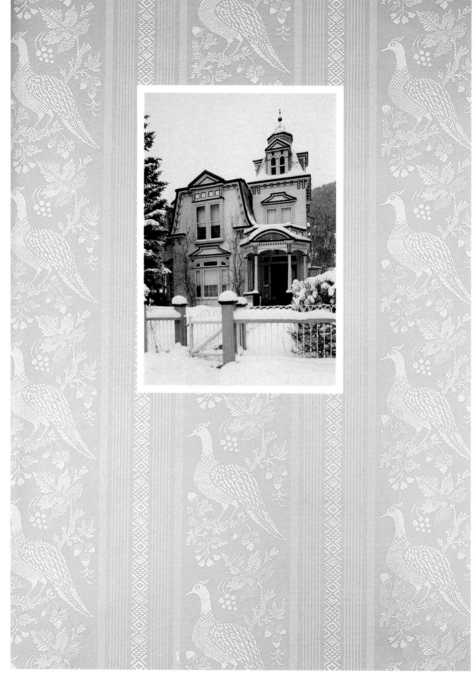

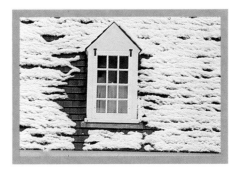

I call architecture
frozen music.

Johann Wolfgang von Goethe

It is a truth
universally acknowledged,
that a single man in possession
of a good fortune,
must be in want of a wife.

Jane Austen

A s with the commander of an army or the
leader of any enterprise, so it is with the
mistress of the house. Her spirit will be seen
through the whole establishment; and just in
proportion as she performs her duties, intelligently
and thoroughly, so will her domestics follow
in her path.

Beeton's Book of Household Management

If parents wish their daughters to grow up with
good domestic habits, they should have, as
one means of securing this result, a neat and
cheerful kitchen.

The American Woman's Home

Thoughts of Family

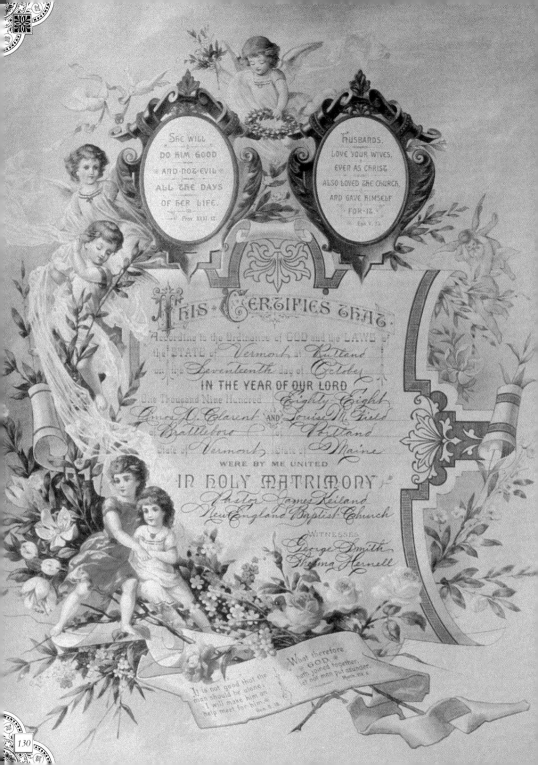

She Will
Do Him Good
And Not Evil
All The Days
Of Her Life.
— Prov. XXXI. 12.

Husbands,
Love Your Wives,
Ever As Christ
Also Loved The Church,
And Gave Himself
For It.
Eph. V. 25.

This Certifies That

According to the Ordinance of GOD and the LAWS of
the STATE of Vermont at Rutland
on this Seventeenth day of October

IN THE YEAR OF OUR LORD

One Thousand Nine Hundred Eighty Eight

Amos A. Clarent AND Louise M. Field
of Brattleboro of Portland
State of Vermont State of Maine

WERE BY ME UNITED

IN HOLY MATRIMONY

Pastor James Keiland
New England Baptist Church

Witnesses
George Smith
Thelma Hernell

What therefore
GOD
hath joined together,
let not man put asunder.
Mark X. 9.

It is not good that the
man should be alone;
I will make him an
help meet for him.
Gen. II. 18.

The sum which two married people owe to
one another defies calculation. It is an
infinite debt, which can only be discharged
through all eternity.

Johann Wolfgang von Goethe

Reflections on Marriage

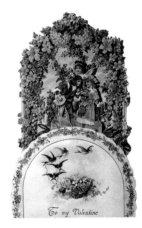

To my Valentine

inter, a lingering season, is a time to gather golden moments, embark upon a sentimental journey and enjoy every idle hour.

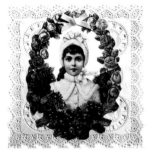

e cannot tell the precise moment when friendship is formed. As in filling a vessel drop by drop, there is at last a drop which makes it run over; so in a series of kindnesses there is at last one which makes the heart run over.

John Boswell

Cherished Thoughts

SCENTED WATER

In earlier times, household linens were laundered, then rinsed in water perfumed with sweet herbs from the garden. To make scented water, use herbs such as lemon balm, mint, rosemary, or sweet marjoram. Place the herbs in a saucepan and add water to cover. Bring to a boil, cover the pan, and remove from the heat. Allow water to cool to lukewarm, strain it into a bottle or jar, and seal tightly. To use, pour the water directly into the washing machine during the rinse cycle. Scented water will keep for several days in a cool, dry place or refrigerated.

It is only with the heart that one can see rightly; what is essential is invisible to the eye.

Antoine de Saint-Exupéry

Cherished Thoughts

A DEDICATION TO MY WIFE

To whom I owe the leaping delight
 That quickens my senses in our wakingtime
And the rhythm that governs the repose of our sleepingtime,
 The breathing in unison

Of lovers whose bodies smell of each other
Who think the same thoughts without need of speech
And babble the same speech without need of meaning.

No peevish winter wind shall chill
No sullen tropic sun shall wither
The roses in the rose-garden which is ours and ours only

But this dedication is for others to read:
These are private words addressed to you in public.

T. S. Eliot

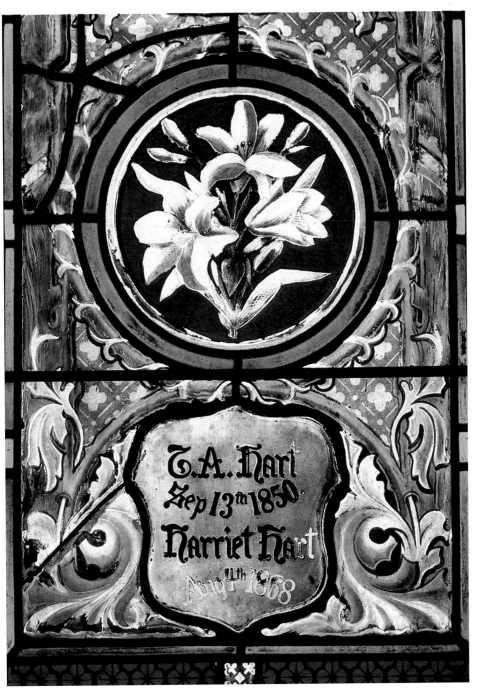

T.A. Hart
Sep 13th 1850
Harriet Hart
Aug 4th 1868

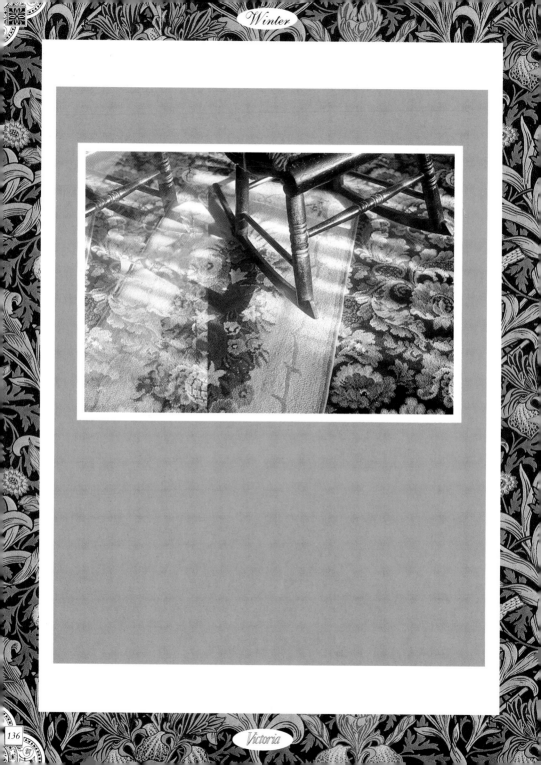

*You do not need to leave your room.
Remain sitting at your table and listen.
Do not even listen, simply wait. Do not
even wait, be quite still and solitary. The
world will freely offer itself to you to be
unmasked, it has no choice, it will roll in
ecstasy at your feet.*

Franz Kafka

TO MY SISTER

It is the first mild day of March:
Each minute sweeter than before,
The redbreast sings from the tall larch
That stands beside our door.

There is a blessing in the air,
Which seems a sense of joy to yield
To the bare trees, and mountains bare,
And grass in the green field.

My Sister! ('tis a wish of mine)
Now that our morning meal is done,
Make haste, your morning task resign;
Come forth and feel the sun.

Edward will come with you—and, pray,
Put on with speed your woodland dress,
And bring no book; for this one day
We'll give to idleness.

No joyless forms shall regulate
Our living calendar;
We from today, my Friend, will date
The opening of the year.

Love, now a universal birth,
From heart to heart is stealing;
From earth to man, from man to earth:
—It is the hour of feeling.

One moment now may give us more
Than years of toiling reason;
Our minds shall drink at every pore
The spirit of the season.

Some silent laws our hearts will make,
Which they shall long obey;
We for the year to come may take
Our temper from today.

And from the blessed power that rolls
And, below, above,
We'll frame the measure of our souls:
They shall be tuned to love.

Then come, my Sister! Come, I pray,
With speed put on your woodland dress;
And bring no book: for this one day
We'll give to idleness.

William Wordsworth

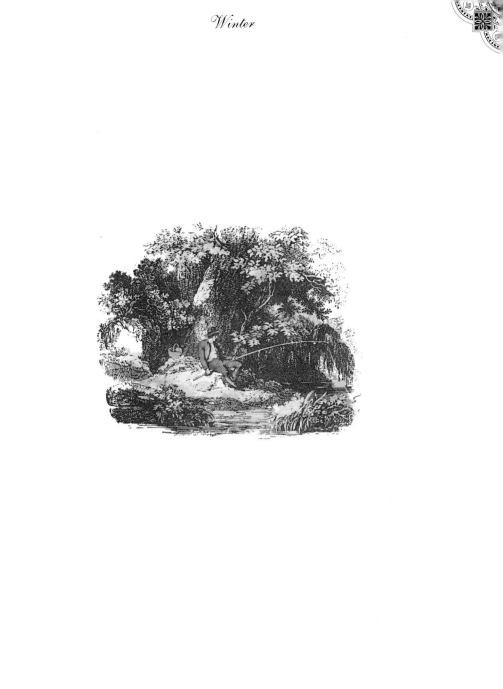

9 Portrait of Queen Victoria. Photograph by Bryan E. McCay.

SPRING

10–11 Background photograph by Jeff McNamara. Excerpt from "Sonnets from the Portuguese" by Elizabeth Barrett Browning, 1850. Photograph of Victorian house in Norwalk, Connecticut, by John Kane.

12 Photograph taken on Block Island by John Kane. Mark Twain's remarks are from a speech he delivered to The New England Society on December 22, 1876.

13 Excerpt from "Atalanta in Calydon" by Algernon Charles Swinburne, 1865.

14–15 Excerpts from: *Felix Holt, The Radical* by George Eliot, 1866; "Pudd'nhead Wilson" by Mark Twain, 1894; "The Ecstasy" by John Donne, 1598. Photographs by Toshi Otsuki.

16–17 Background photograph by Toshi Otsuki. Excerpt from preface poem to *Look Homeward, Angel* by Thomas Wolfe, 1929. Copyright 1929 Charles Scribner's Sons; renewal copyright © 1957 Edward C. Aswell, as Administrator, C.T.A. of the Estate of Thomas Wolfe, and/or Fred W. Wolfe. Archway photograph by Thomas Hooper.

18 Photograph of a home in Kentucky by Jim Hedrich. Excerpt from *The Velveteen Rabbit* by Margery Williams.

19 Excerpt from *The Tale of Peter Rabbit* by Beatrix Potter, 1902.

20 A distinctive church by William Critchlow Harris on Prince Edward Island, Canada. Photograph by Toshi Otsuki. Excerpt from *Anne of Green Gables* by L.M. Montgomery, 1908.

21 Poem #1052 by Emily Dickinson, c. 1865.

22 Photograph by Toshi Otsuki. Excerpt from *The Marriage of Heaven and Hell*, "Proverbs of Hell," by William Blake, 1790.

23 Photograph by Jon Jensen. Excerpt from "The Prisoner of Chillon" by Lord Byron, 1816.

24 Photograph by Tina Mucci. Excerpt from *Wilhelm Meisters Lehrjahre (Apprenticeship)* by Johann Wolfgang von Goethe, 1800.

25 Photograph by Toshi Otsuki. Excerpt from

"Afternoon on a Hill" by Edna St. Vincent Millay, 1917.

26 Photograph by Toshi Otsuki.

27 Photograph by Bryan E. McCay. "A Thing of Beauty" is from *Endymion, A Poetic Romance* by John Keats, 1818.

28 Flower-lined path on Prince Edward Island, Canada, photographed by Toshi Otsuki. Excerpt from *Anne of Green Gables* by L.M. Montgomery, 1908.

29 Photograph by Toshi Otsuki. Excerpt by Anaïs Nin from a letter to her mother dated March 1937.

30 Excerpt from *Memorial Verses* by Matthew Arnold, 1850.

31 Photograph by Toshi Otsuki. Excerpt from *The Web and The Rock* by Thomas Wolfe. Copyright 1937, 1938, 1939 by Maxwell Perkins as the Executor of the Estate of Thomas Wolfe. Renewed 1965 by Paul Gitlin, C.T.A./ Administrator of the Estate of Thomas Wolfe. Reprinted by permission of Harper & Row, Publishers, Inc.

32 "All Through the Night" is a children's nursery rhyme.

33 Background photograph of pressed paper by John Vaughan. Photograph entitled *Attic 5: The Buggy* by Norm Darwish.

34 Photograph by Bryan E. McCay. Excerpt from "The Princess" by Alfred, Lord Tennyson, 1847.

35 Excerpts from Sonnet 8 by William Shakespeare; *Her Son's Wife* by Dorothy Canfield Fisher, 1926; *Hermann und Dorothea* by Johann Wolfgang von Goethe, 1797.

36 Excerpts from: "The Wish" by Roger de Bussy-Rabutin, 1647; Dedication to *A Bad Child's Book of Beasts* by Hilaire Belloc, 1896; *The Story of My Life* by Helen Keller, 1902.

37 Photograph taken in Chautauqua, New York, by Toshi Otsuki. Poem by Catullus from *Carmina LXX.*

38 Illustration by Childe Hassam from *An Island Gardener* by Celia Thaxter, published by Houghton Miflin Co., Boston, in 1894. Reprinted

by special arrangement with Houghton Miflin Company. Excerpt from *An Island Gardener* by Celia Thaxter, 1894.

39 Excerpt from "On Leveling All Things" by Chuang-tau (369–286 B.C.).

40 "My Beth" from *Little Women* by Louisa May Alcott, 1868.

41 Photograph by Carin Krasner.

SUMMER

42–43 Excerpt from "What Lips My Lips Have Known" by Edna St. Vincent Millay, 1923. Photograph by Bryan E. McCay.

44 Excerpt from *Walden* by Henry David Thoreau, 1854.

45 Photograph by John Kane. Excerpt from "Journals" by Henry David Thoreau.

46 Flower photograph by John Vaughan. Excerpt from *The Little Prince* by Antoine de Saint-Exupéry, 1943. Copyright 1943 and renewed 1971 by Harcourt Brace Jovanovich, Inc.; reprinted by permission of the publisher.

47 Illustration by Childe Hassam from *An Island Gardener* by Celia Thaxter, published by Houghton Miflin Company, Boston, in 1894. Reprinted by special arrangement with Houghton Miflin Company.

48 Photograph by Bryan E. McCay. Excerpt from *Vesalius in Zante* by Edith Wharton.

49 Excerpt from *The Great Gatsby* by F. Scott Fitzgerald, 1925.

50–51 Excerpt from "Pastorals" by Alexander Pope, 1704. Photograph taken in Central Park by Toshi Otsuki for his *Central Park Series*, 1979.

52–53 Photographs by Bryan E. McCay. Excerpts from: *A Backward Glance* by Edith Wharton, quoting Henry James, 1934; *Alice's Adventures in Wonderland* by Lewis Carroll, 1865. Photograph of roses and books by John Vaughan. Lavender photograph by Chris Mead.

54 Photograph by Bryan E. McCay.

55 "On Children" is reprinted from *The Prophet* by Kahlil Gibran, by permission of Alfred A. Knopf, Inc. Copyright 1923 by Kahlil Gibran and renewed 1951 by Administrators C.T.A. of Kahlil Gibran Estate, and Mary G. Gibran. Excerpt from *Alice's Adventures in Wonderland* by Lewis Carroll, 1865.

56 Excerpt from *Tess of the D'Urbervilles* by Thomas Hardy, 1891.

57 Photograph by John Kane.

58 Statue photographed at the Gardiner Museum in Boston, Massachusetts by Toshi Otsuki. Excerpt from *Look Homeward, Angel* by Thomas Wolfe, 1929. Copyright 1929 Charles Scribner's Sons; renewal copyright © 1957 Edward C. Aswell, as Administrator, C.T.A. of the Estate of Thomas Wolfe, and/or Fred W. Wolfe.

59 Wall hanging, also from the Gardiner Museum, photographed by Toshi Otsuki. Excerpt from *Mrs. Dalloway* by Virginia Woolf, copyright 1925 by Harcourt Brace Jovanovich, Inc. and renewed 1953 by Leonard Woolf; reprinted with permission of the publisher.

60 Photograph by Keith Scott Morton. Excerpt from Algernon Charles Swinburne, "A Match," 1866.

61 Excerpts from: Edward FitzGerald, "The Rubaiyat of Omar Khayyam," 1879; Pierre de Ronsard, "Sonnets Pour Hélène," c. 1580; Rubén Darío, "I Seek a Form," from *Profane Hymns and Other Poems*, 1896. Translated by Lysander Kemp; Thomas Moore, "Spring and Autumn," from *National Airs*, 1815. Photograph of kittens and roses by Toshi Otsuki. Needlepoint purse designed by Janet McCaffrey and photographed by Bryan E. McCay.

62 Summer-landscape photograph by Toshi Otsuki. Sonnet 18 by William Shakespeare.

63 Photograph by Toshi Otsuki.

64 Photograph by Jim Hedrich. Excerpt from *Remembrance of Things Past, Swann's Way* by Marcel Proust, 1913. Copyright 1928 by The Modern Library, Inc. Copyright renewed 1956 by The Modern Library, Inc.

65 Photograph by John Kane. Excerpt from *Madame Bovary* by Gustave Flaubert, 1857.

66 Chromolithograph based on watercolor by Childe Hassam from *An Island Garden* by Celia Thaxter. Copyright, 1894 by Houghton Mifflin Company. Reprinted by permission. A facsimile edition of *An Island Garden* was published in 1988 by Houghton Mifflin Company.

67 Photograph of little girl in bonnet by Toshi Otsuki. "Nature" by Henry Wadsworth Longfellow, 1875.

68 Photograph by Lilo Raymond. Excerpt from *Water Babies* by Charles Kingsley, 1863.

69 Excerpt from "Song of Myself," by Walt Whitman, 1855.

70 "There is a Garden in Her Face," a poem by Thomas Campion, 1617.

71 "The Flower Girl," 1920, a painting by Helen Turner (1858–1958). Oil on canvas. Copyright © The Detroit Institute of Arts, Gift of the National Academy of Design.

72 Banner from the Gardiner Museum in Boston, Massachusetts, photographed by Toshi Otsuki.

73 Photograph of a house in St. Louis, Missouri by Jim Hedrich. "The Sun Rising" by John Donne.

74 Excerpt from "Sudden Light" by Dante Gabriel Rossetti, 1881.

75 Photograph by Bryan E. McCay.

A U T U M N

76 Excerpt from "Come, Ye Thankful People, Come," by Henry Alford, 1844.

77 Wreath photograph by Carin Krasner.

78 Train interior by Toshi Otsuki. "Travel," by Edna St. Vincent Millay, 1921.

79 Train detail by Thomas Hooper. *Travels with Charley*, John Steinbeck. Copyright © 1962 by Viking Press.

80 Sampler, circa 1803, from the Severson family, San Francisco, California. Photograph by John Vaughan.

81 Excerpt by Richard Horn was published in *Victoria*.

82 Photograph by Toshi Otsuki.

83 Clock from the home of Charlotte Brontë. Photograph by William P. Steele. Excerpt from *One Writer's Beginnings* by Eudora Welty, Harvard University Press, 1983. Reprinted with permission.

84 Excerpts from: *Essays* by Michel Eyquim de Montaigne, 1580; "Christabel" by Samuel Taylor Coleridge, 1797; "Pudd'nhead Wilson" by Mark Twain, 1894.

85 Excerpt from *Particularly Cats* by Doris Lessing, 1967. Copyright © 1967 Doris Lessing Productions Ltd. Reprinted by permission of Jonathan Clowes Ltd., London, on behalf of Doris Lessing. Photograph by John Kane.

86 Photograph by Jim Hedrich. Excerpt from "Autumn" by Thomas Hood, 1827.

87 Photograph by Bryan E. McCay. Excerpt from "The Wind Among the Reeds" by William Butler Yeats, 1899.

88–89 Excerpt from *Tess of the D'Urbervilles* by Thomas Hardy, 1891. Photograph by Tina Mucci.

90 "The Ferns of Wales" by Edward Young.

91 Excerpt from *Stuart Little* by E. B. White. Copyright © 1945 by E. B. White. Copyright renewed 1973 by E. B. White.

92–93 Excerpts from: "The Autumnal" by John Donne, 1600; "Hymn to Intellectual Life" by Percy Bysshe Shelley, 1816. Photograph by Bryan E. McCay. Herbal Vinegar recipe reprinted from *Seasonal Gifts from the Kitchen* by Emily Crumpacker, William Morrow, 1983. Dried-herbs photograph by Bryan E. McCay. Drying Flowers and Herbs from *Country Living Country Decorating*. Farmhouse photograph by Toshi Otsuki. Excerpt from "Rigby Chapel" by Matthew Arnold, 1867.

94 Photograph by John Kane. Excerpts from: "When the Frost is on the Punkin," by James Whitcomb Riley, 1911; "Autumn (Resignation)" by Humbert Wolfe, 1926.

95 Photograph of Cabbagetown, Toronto, Canada, by John O'Brien.

96–97 Possessions of a Victorian woman's sewing workbox. Photograph by Starr Ockenga. "Curlylocks" is a children's nursery rhyme.

98 Photograph by Toshi Otsuki. *David Copperfield* by Charles Dickens, 1850.

99 "The Everlasting Gospel" by William Blake, 1818.

100 Excerpts from: "Astrophel and Stella" by Sir Philip Sidney, 1591; *Lettres Provinciales* by Blaise Pascal, 1656–7; "Othello" by William Shakespeare, 1604; *Pickwick Papers* by Charles Dickens, 1836–7.

101 Memorabilia of the calligrapher Platt Rogers Spencer from the Geneva Public Library, Ohio. Photograph by Jim Hedrich.